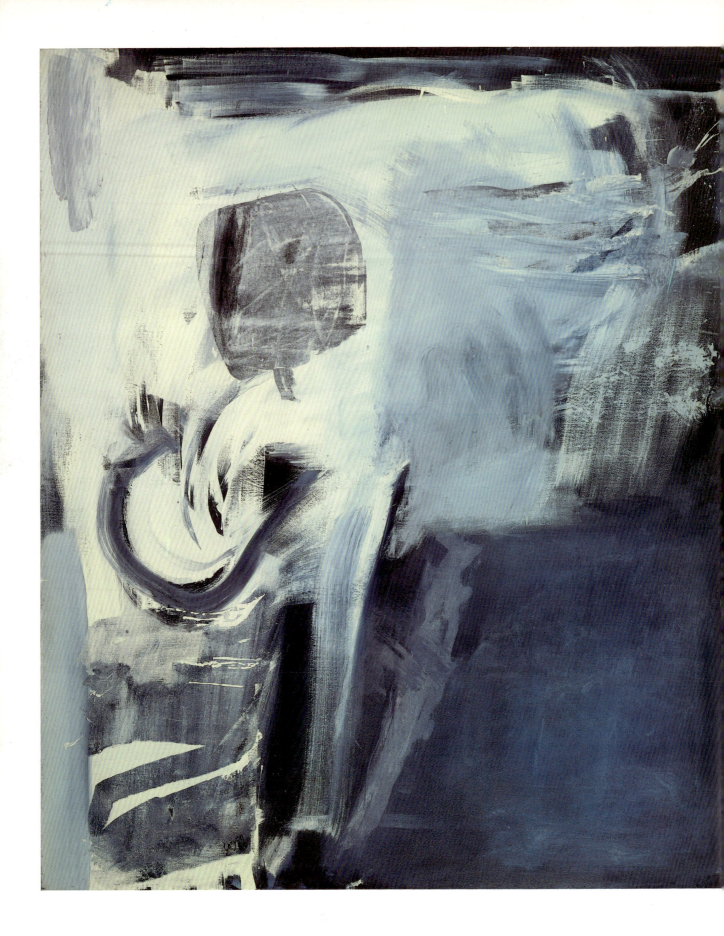

Michael Tooby

An Illustrated Companion

Tate Gallery St Ives
Barbara Hepworth Museum
and Sculpture Garden

TateStIves

Tate Gallery

ISBN 1 85437 118 5

Published by order of the Trustees 1993
Designed by Pentagram
Published by Tate Gallery Publications, Millbank,
London SW1P 4RG
© 1993 Tate Gallery All rights reserved
Printed and bound in Great Britain by
Balding + Mansell, Wisbech, Cambridgeshire

Copyright Credits

Works of Art
Forbes (p.16) Newlyn Gallery; Morris (p.17) Michael
Chase; Nash (p.29) Paul Nash Trust; Gabo (p.37) Nina
Williams; Davie (p.49) Gammells Studio; Frost (pp.55,
67, 76, 89) The Artist; Wells (p.68) The Artist; Wescke
(pp.86, 87) The Artist

Photographs
Gasworks (p.11) Toni Carver; Artists' show day (p.20)
Evan Bladford; Nicholson's studio (p.27) Alan Bowness;
Wallis's grave cover (p.34) Evan Blandford; Crypt
Group (p.42) Central Office of Information; Portrait of
Lanyon (p.50) Evan Blandford; Portrait of Leach (p.82)
Bernard Leach Archive

Frontispiece:
Peter Lanyon *1918-1964*
Thermal 1960
Oil on canvas
182 × 152.4 (71 × 60)
Purchased 1960
T00375

Measurements of works are given in centimetres
followed by inches in brackets; height before width

Contents

Foreword

The Tate Gallery St Ives project is unique. It allows the visitor to see the works of art in the area in which they were conceived and close to the landscape and sea which influenced them. When the concept of a new gallery in St Ives to house the internationally known school of St Ives was suggested, Cornwall County Council seized the opportunity not only to exhibit the works of art but also to house them in a gallery of architectural distinction. Cornwall, after all, has a long artistic tradition and in this century has produced two schools of painting of international renown – Newlyn and St Ives. The former gasworks site, on which the gallery stands, gave a perfect opportunity for a highly imaginative, stimulating and interesting design. The chosen architects, Evans and Shalev, rose to the challenge, conceiving an exciting building full of interest with its open spaces, detailed interior design and breathtaking views of the sea and Penwith moors.

The Gallery is a source of great pride and, as well as being an achievement which reflects a wide body of support is a tribute to those locally who raised over £130,000 towards the cost of construction of the building and the equipping of the education room. The Gallery will provide a focus for the local community and will be a source of inspiration to artists living in or visiting St Ives and West Cornwall. It will work with and complement older established galleries in Cornwall. Its educational programme will be a valuable resource and encouragement for students of all ages. Above all, it is a sign of what can be achieved by different communities and groups working together.

Sir Richard Carew Pole
Chairman, Cornwall County Council
Tate Gallery St Ives Steering Group

Director's Foreword

Since the mid-nineteenth century two 'schools' of art have grown up in West Cornwall, at Newlyn and at St Ives. The existing public galleries in Penzance and Newlyn provide for the display of Newlyn School painting but no similar permanent arrangement has hitherto existed for St Ives. The idea of a permanent home in the region for the distinctive modern art of St Ives has long been cherished by many who live in or visit the area. The Tate Gallery St Ives is the realisation of that idea. The involvement of the Tate in this project reflects the fact that, whilst it holds only a small group of major Newlyn School paintings, its holdings of painting and sculpture from St Ives are rich and broad, capable of providing changing displays of variety and quality at a new gallery.

But the dream of a gallery for St Ives also chimed well with the Tate's declared policy of presenting the national collections of British and Modern Art to diverse audiences, including the development of galleries away from London. That is why the Trustees agreed to take responsibility for the gallery that Cornwall County Council had committed to build. The St Ives Tate Action Group (STAG) co-ordinated local support and fundraising, and with its many dedicated individual members was crucial in enabling the project to get started. Cornwall County Council gained the interest of a range of local, national and European bodies, and led fundraising from trust and corporate sectors. An architectural competition was held and from a strong field Eldred Evans and David Shalev, who had recently completed the prizewinning Truro County Courts, were appointed as architects for the new building. A Steering Group was established to supervise continuing fundraising and the construction of the building.

This publication appears on the occasion of the completion of the building and the opening of the first displays at Tate Gallery St Ives in June 1993.

The Tate Gallery St Ives will present twentieth-century art in the context of Cornwall. At the heart of its programme of displays and activities will be the body of work for which the town of St Ives is internationally known, the modernist art made in St Ives, or by artists associated with the town and its surrounding area, from the 1920s onwards. The Gallery's displays will reflect the many different ways this body of work may be understood. Works of art will be seen with varied comparative material. The Gallery will also present new works made by younger artists, responding to the Gallery's displays or to the broader Cornish scene.

The Tate Gallery will continue to acquire work for its collections, and remains committed to showing works associated with Cornwall in both London and Liverpool, as well as in St Ives. Moreover, the links between the art and artists of West Cornwall and other centres for making and showing art around the world will mean that Tate Gallery St Ives will also display related works by non-Cornish artists as an integral part of its programme.

The Barbara Hepworth Museum and Sculpture Garden, which opened in 1976 and came under the wing of the Tate in 1980, is now part of Tate Gallery St Ives. The displays in the Gallery will be complemented by a more permanent installation at the Hepworth Museum: changing views set out by curators and artists in one place will contrast with a coherent personal vision in the other. All displays will be augmented by a full programme of educational and community projects, usually involving artists, within and outside both buildings. This is a venture which began in the studios of St Ives and West Penwith; it is now a project which will enrich the lives of all who visit or live in the area.

Nicholas Serota
Director, Tate Gallery

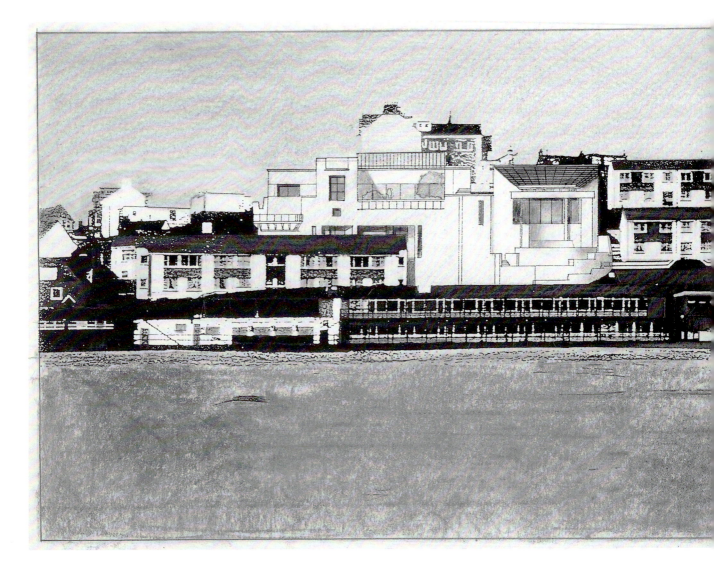

A design drawing of the Tate Gallery
St Ives by Evans and Shalev

Introduction

This publication is an introduction to Tate Gallery St Ives, which as it has no single static collection changes its display annually. The boundaries for defining displays will undoubtedly change and develop. As works leave for other displays and exhibitions, or arrive as new acquisitions and long loans, and as new works by younger artists emerge, the picture the Gallery presents of modern art in the Cornish context will fracture and evolve.

Reproduced and discussed here are many of the works in the Gallery's opening displays, together with a selection of paintings and sculpture which will be shown during the first few years. The book is structured to provide a chronological introduction to St Ives art, and a discussion of what is meant by that term. Each chapter has an introductory essay, followed by a more detailed look at a selection of individual works. This first publication will be augmented by other publications and interpretative material which will look in greater depth at the subjects covered here, at other issues, and at works by other artists.

One of the objectives of Tate Gallery St Ives is to enable an expanding audience to come to a greater understanding and enjoyment of modern art. Through its changing displays and its education programme the new Gallery and the Hepworth Museum will offer a variety of routes to further enquiry.

The process of making publications and gallery displays tends to freeze one version of events, but many of the artists who are featured here – as well as many others who are not – continue to live and work in St Ives. It is important to remember that this publication, like any other book about art, is only intended as an adjunct to the reader's personal experience.

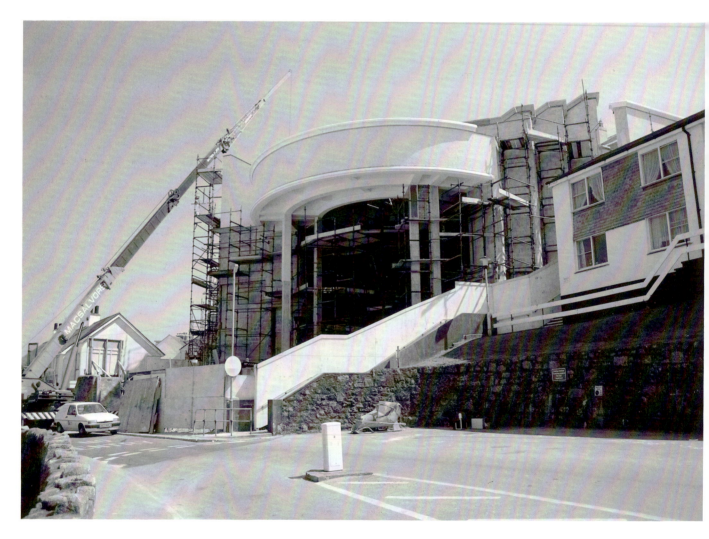

Tate Gallery St Ives under construction

The New Building

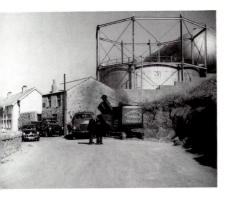

The gasworks, Porthmeor Beach
c.1963

It may be hard for new visitors to Tate Gallery St Ives to imagine that it is built on the site of the town's old gasworks. The site had, by the 1980s, become derelict and dangerous. However, it presented obvious attractions as a site for a future gallery of modern art: it overlooks Porthmeor Beach, but is also close to the old town around the harbour and the modern development to the north-west, including the streets where artists have lived and worked for four generations.

Since they began working together in 1965, the architects Evans and Shalev have divided their time between their base in London and a home in St Ives, where Evans's father, the painter Merlyn Evans, spent much time. Eldred Evans studied at the Architectural Association in London, and at Yale University. David Shalev studied at Technion in Israel.

Their previous work has been distinguished by an architectural language that brings together the spaciousness, clarity and simplicity of the modern movement with a wit and human quality that is born of a strong sense of a building's relationship to its context and use. They have remarked of themselves that they 'are single minded modernists with the conviction that a building, built to last, is rooted in its time and place'.

In St Ives, Evans and Shalev took two basic forms that echo those on the original site: a cylinder, recalling the old gas holder, and a rising solid rectangle which relates the building to the earlier developments along Porthmeor Beach.

The route they have designed through the building recalls the atmosphere of the old Downalong area of the town: simple stepped paths or narrow entrances, giving onto remarkable clear spaces, the surrounding dramatic scenery disclosed through surprising chinks, or revealed by terraces and opened-out viewpoints. The galleries themselves are each a different shape and volume: as the architects say, 'flexibility in use is achieved not by creating an endlessly flexible anonymous structure, but by designing a set of unique rooms'.

The detailing of the building reflects the modernist tradition that is central to St Ives: white walls, plain frosted or clear glass windows, simple wood and slate finishes. However, the way the architects considered the site is revealed by the elevation visible from Back Road West. If you stand near Alfred Wallis's house or the Porthmeor studios, the Gallery rises in a series of broken planes, windows, and ledges, ending in the pitched slate roof, as if it were growing from the clusters of buildings around it. This reveals their aim that 'the experience of visiting the Gallery ought to be a natural extension of visiting St Ives and thus provide some insight into the artists' inspirations and aspirations on this remote and magical island'.

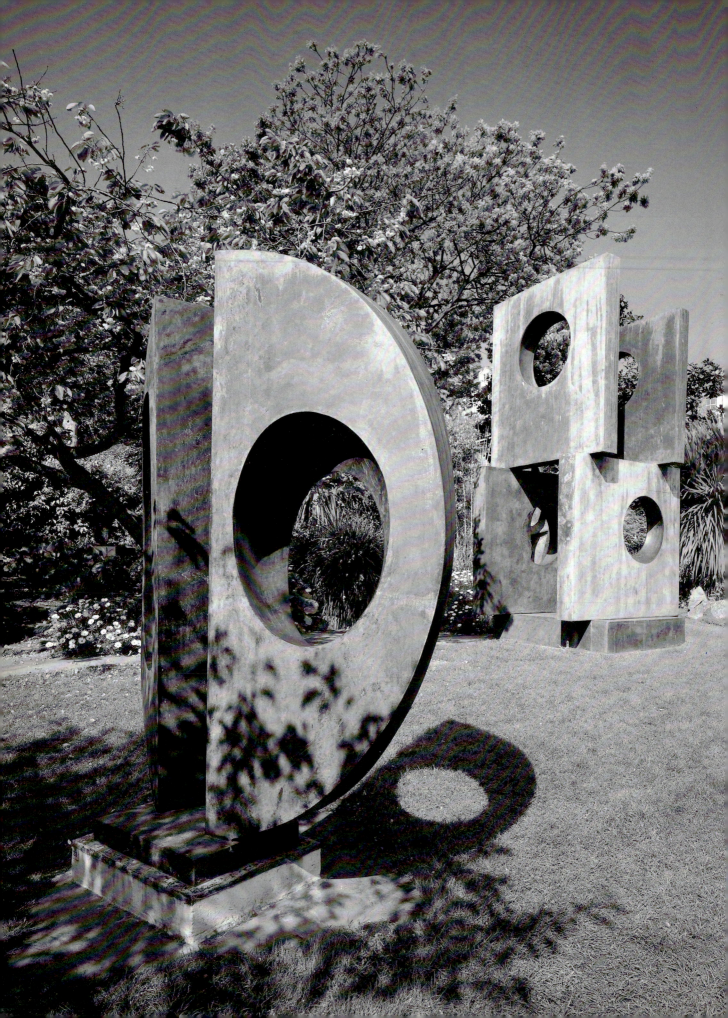

The Barbara Hepworth Museum and Sculpture Garden

eft, above and right:
Three views of the Sculpture Garden

When Barbara Hepworth died in 1975, the Trustees of her estate followed her wish to establish her home and studios as a museum of her work. The museum and garden, together with much of the artist's work in them, were given to the nation in 1980, and placed in the care of the Tate Gallery.

Barbara Hepworth worked in Trewyn Studios from 1949, ten years after she first arrived in West Cornwall. From 1953 until her death she also lived there. On the ground floor of the house was a wood-carving studio, where new work was roughed out and finished. In the adjoining outbuildings was a stone-carving

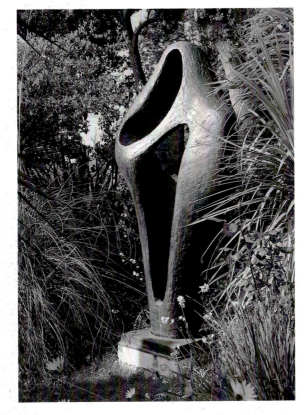

studio, and a studio for making plaster models and casting in bronze. By the end of her life, the upstairs room was both a day-to-day living room and a workshop where sculpture in different states of finish was worked on.

Today this upstairs room houses a group of pieces chosen by the artist's family and the then Director of the Tate Gallery, Sir Norman Reid, to represent the different stages of her career. The display also includes examples of her very earliest work, from the 1920s, and work from the 1930s, before she moved to St Ives.

When Barbara Hepworth first arrived at Trewyn studios she was still largely preoccupied with the stone and wood carving which was central to her work. But during the 1950s she increasingly made sculpture in bronze. This led her to a more diverse range of scale, and to a more industrial and mechanical approach to fabrication. As her work in bronze developed, Hepworth used her garden, initially laid out with the help of a friend, the musician Priaulx Rainier, as a viewing area for larger work. Some of the bronzes now in the garden may be familiar to visitors from casts situated elsewhere, but here they are seen in the environment in which they were created.

The museum and garden give a powerful and moving impression of the way Barbara Hepworth worked while living in St Ives.

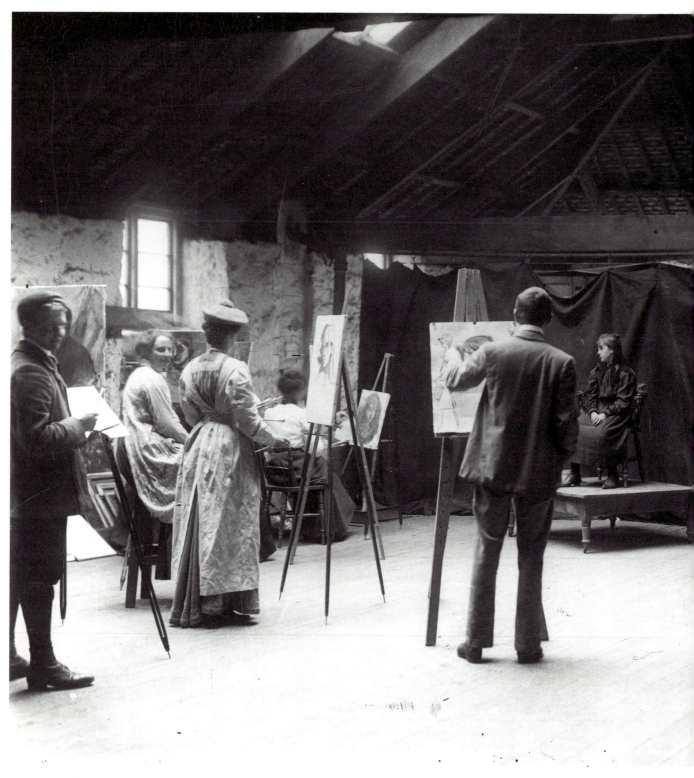

An art school in St Ives c.1900.
Emily Carr is on the left wearing a
tam-o'-shanter

J.M.W. Turner **St Ives** 1811 from the
Bude to Clovelly sketchbook (TB CXXV
A-49) *Turner Bequest*

Any account of modern art in Cornwall must begin by acknowledging a three thousand year legacy of human activity in the region now known as West Penwith. The extraordinary presence of Bronze Age standing stones and Celtic carvings and sculpture, as well as the heritage of indigenous craft traditions, have regularly surfaced in art made in the region in the twentieth century. Nevertheless, most histories of modern art in Cornwall begin by noting Turner's visit to the county in 1811. Turner's sketches attest to the natural beauty of the region and the romance of visiting the furthest flung limb of southern England. They inaugurate the dialogue between artist and landscape that dominates the subsequent history of art in the region.

Throughout the nineteenth century art production in Cornwall developed in a way characteristic of many regions of Britain: there were indigenous practising artists, there were locally trained successes who found their way to London, and there were well-known visitors alighting in the region for sketching forays. The way in which such regional centres evolved their own identity in the Victorian era is inevitably bound up with their economic and social development. The booming towns of the Midlands and North of England, such as Birmingham, Manchester, or Newcastle-upon-Tyne, witnessed a fruitful dialogue between classically trained artists, drawn to London by the availability there of academic training, critical debate and

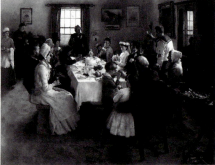

Top:

Frank Bramley **A Hopeless Dawn**
1888 *Tate Gallery* Presented by the
Trustees of the Chantrey Bequest 1888
(N01627)

Above:

Stanhope Alexander Forbes **The
Health of the Bride** 1889 *Tate Gallery*
Presented by Sir Henry Tate 1894
(N01544)

patronage, and those whose loyalties to their home towns generated local artistic traditions or led to the development of local schools for art and industrial design.

Over the same period the communities that were to become artists' 'colonies', many of them fishing communities, such as Staithes on the north-east coast, saw great changes. Indigenous economic activity levelled off and eventually declined. And while the new industrial centres and emigration attracted away those looking for new opportunities, the railways in turn brought remote areas of the country within reach of the new urban centres, as places of retreat and recreation.

The Great Western Railway arrived in St Ives in 1877. A new phase of development in the town saw building such as the magnificent new Tregenna Castle Hotel and the spacious terraced housing in the higher reaches surrounding the harbour – giving rise to the terms of Upalong and Downalong to describe the town's new and old quarters. It was at this time, between 1880 and 1900, that the mix of long-term residents and occasional visitors established itself as a continuing pattern in the life of the art colony.

Thus J.A.M. Whistler, Walter Sickert and Mortimer Menpes spent a winter in St Ives in 1883-4. The sketches by Whistler attributed to this visit are beautiful, simple reveries, often responding to the still clarity which overtakes the north-west sky facing Porthmeor Beach and Clodgy Point, after the squalls which rush over them the year round.

The Newlyn School is generally considered to have been formed between 1882 and 1886, when Walter Langley, Stanhope Forbes, T.C. Gotch and many others settled in the town across the

Penwith Peninsula from St Ives. They were indebted to French painters, such as Bastien Lepage, who practised a rigorous application to the day-to-day realities of the life they saw around them: workers pausing in the street, sheets of rain drenching all alike. As Forbes wrote in 1898:

Those were the days of unflinching realism, of the cult of Bastien Lepage. It wa part of our artistic creed to paint our pictur directly from Nature, and not merely to rely upon sketches and studies which we could after wards amplify in the comfort of the studio.

However, in the comfort of the studi the large 'machines' (exhibition pictures into which the 'unflinching realism' evolved, took on an increasingly dramat – and on occasion melodramatic – nature. This led to popular success: Frank Bramley's 'A Hopeless Dawn' was the hit of the 1888 Royal Academy and was purchased from that exhibition for the nation by the Chantrey Bequest. Forbes's 'The Health of the Bride' was bought from the Royal Academy in 188 the year it was painted, and in 1894 wa one of the works presented to the natio by Sir Henry Tate to found the gallery named after him. This success in turn generated celebrity for the town of Newlyn, where J. Passmore Edwards provided the funds for the establishmen of an art gallery, and visitors flocked to studio open days.

The first wave of artists to establish S Ives as their base came from more varie backgrounds than the Newlyn painters. The first year-round fully fledged studio in the town are generally thought to be those taken up by Harewood Robinson and William Eadie in 1885. The year after, a group including Louis Grier and the American E.E. Simmons arrived. They established the St Ives Arts Club

in 1888, opening a permanent building for it in 1890. In 1887 James Lanham opened a room in his general merchants' and artists' materials shop, as a gallery for local artists. Julius Olsson helped to establish the Porthmeor Studios and the 'atelier' style school which ran in it. He, Alfred East, Algernon Talmage and W.H.Y. Titcombe all found success in major London exhibitions.

By 1902, the colony in St Ives was sufficiently well established to be included in a survey of art from West Cornwall in the opening exhibition programme of the new Whitechapel Art Gallery in London. The exhibition catalogue was introduced by an essay by the painter Norman Garstin. His daughter, Alathea Garstin, was one of the second generation of artists who took on the French connection with Cornwall to embrace post-Impressionist painting, including Harold and Laura Knight and Ernest and Dod Procter in Newlyn, and John Park, Dorothea Sharp and others in St Ives.

St Ives soon became, together with Newlyn, a place for aspiring artists, often from abroad, to visit early in their careers. This was the result of the fashionable appeal of artists' colonies in remote areas, combined with the availability of studio space and tuition. An additional factor was the professional connections between artists in the teaching institutions in London and those in the colonies. The early cosmopolitan mix of visitors to St Ives has persisted throughout the colony's history.

Between 1900 and the 1920s the town of St Ives gradually came to terms with its status as a resort and working base for artists. Among the prominent British artists who visited Cornwall were Matthew Smith and Charles Ginner, and many others came as students. Traditions grew up within the artistic community at this time. For example there were celebratory train trips to visit the town on the day artists threw open their studios to the public, generally immediately before packing and sending works to the annual exhibitions in London. It was recognised that art was becoming an integral part of the economy of the region.

The experiences of two figures as diverse as the New Zealand born artist Frances Hodgkins and the Canadian Emily Carr reveal some of the problems and possibilities of being in St Ives. Carr arrived in 1901 to study with Olsson in an attempt to find a fresh direction after an enervating period studying in London. Despite making friends with the Irish student Hilda Ferron and the Australian Will Ashton, she could not tolerate Olsson's insistence that his students must work in the full light – 'that horrible glare', she called it – of Porthmeor Beach, and found it virtually impossible to make any work. Only when the master had left for a summer trip did Carr find herself at ease, when Talmage permitted her to paint in the disapproved context of Tregenna Woods: inland, enclosed, dark and wooded.

Frances Hodgkins arrived in St Ives in 1914, stayed throughout the First World War, and benefited from a happy relationship with the artist Moffat Lindner and his wife, whose portrait she painted. She met many of the artists who passed through St Ives, such as Cedric Morris, Lett Haines and Cornelia Dobson, all of whom lived in nearby Mousehole. She eventually left Cornwall in 1920, her career well established.

Top:
Sir Cedric Morris **Frances Hodgkins**
c.1917 Tate Gallery Presented by the
surviving executor of Frances Hodgkins
1984 (T03831)

Above:
Charles Ginner **Porthleven** exh.1922
Tate Gallery Presented by the
Contemporary Art Society 1924
(N03838)

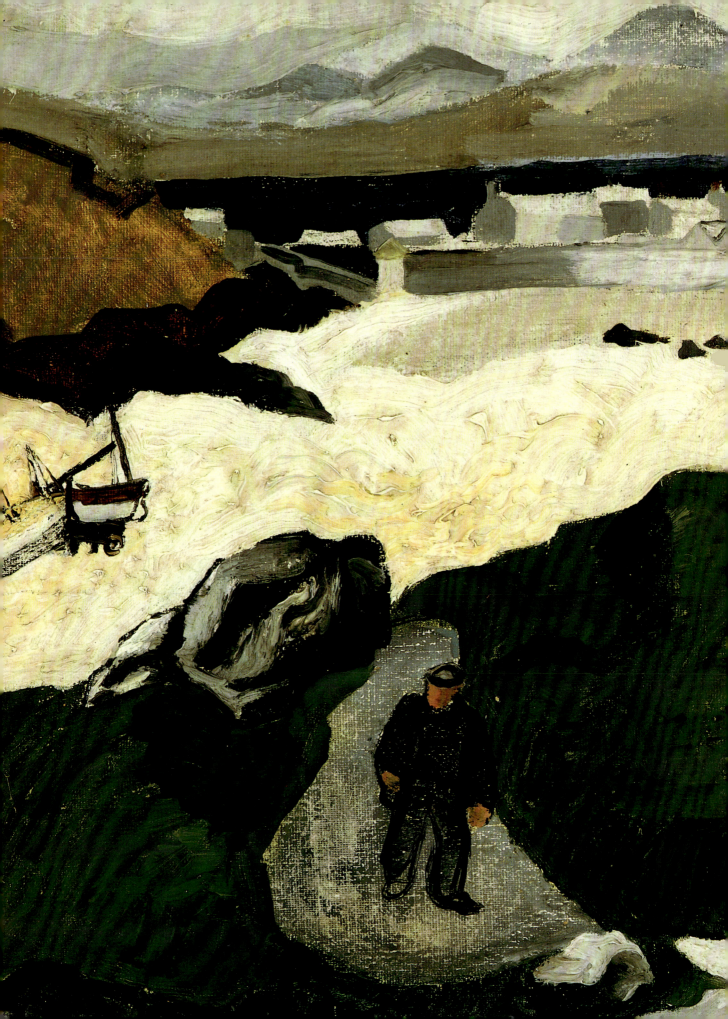

Early Modernism in Britain and Cornwall

above and left (detail):
Christopher Wood *1901-1930*
Porthmeor Beach *1928*
Oil on canvas
46.5 x 55.2 (18 1/4 x 21 3/4)
Michael Nicholson

Ben Nicholson and Alfred Wallis
c.1940. Photograph: Sir John Summerson

On a day trip to St Ives in August 1928, Ben Nicholson and Christopher Wood came across the 'naive' paintings of the retired St Ives seaman Alfred Wallis. Nicholson, his wife Winifred, and Wood had each been experimenting for some time with ways of painting which expressed a purer, more immediate sense of personal vision than did the sophisticated styles of British art that they had grown up with.

Nicholson was the son of the successful painter Sir William Nicholson. At the centre of Edwardian London's artistic life, Sir William was a painter of brilliant portraits, still lifes and landscapes. He was also, as a partner in the Beggarstaff Brothers with Ben's uncle James Pryde, an innovative designer and printmaker. Ben failed to complete an art school training: he amended a draft biography prepared for him by the Tate Gallery in the early 1950s: 'studied ... art ... [by playing billiards at the Gower Hotel round the corner from] ... at ... the Slade ... [for one term] 1910-11.'

In 1920 he married Winifred Roberts. She too had been brought up in sophisticated surroundings, her family being landowners in Cumberland, but like Ben she was seeking a surer, simpler way forward in her life. After their marriage they bought a cottage in Banks Head, on the Roman Wall in Cumberland, near to Winifred's family.

They shared with other artists of their generation an interest in the naive as a way of achieving the simplicity they sought. In 1924 Ben joined an exhibiting society in London, the Seven and Five,

becoming its President in 1926. Winifred joined in 1925 and Seven and Five exhibitions soon were dominated by the Nicholsons, together with artists they identified with, Ivon Hitchens, Cedric Morris and others. In 1927 they met Christopher Wood. He had grown up in prosperous family in Liverpool, and by the time of their meeting was dividing his time between London and Paris. There he met Picasso and was involved with the coterie of artists, writers, musicians and socialites that included Jean Cocteau. It was Cocteau, it is alleged, who introduced Wood to opium. Wood's moods swayed dramatically, and in Winifred and Ben Nicholson's quiet, focused attitudes he found an antidote to the pressures of metropolitan life.

Wood had visited St Ives in 1926, and painted a group of works based on his observations there. His style of drawing, shallow space and pale colours matched his interest in depicting quirky yet moving scenes: a china dog, alert at a cottage window, a fishing boat tossing across a view framed by a pipe on a windowsill.

On a visit to Banks Head in the spring of 1928, Ben, Winifred, and Wood had explored their interest in the naive vision. They had returned to London, then were invited to Cornwall to stay with friends in Feock, on the Fal estuary. The young John Wells, also a guest there, was impressed by their intense sense of purpose. Wood and Ben Nicholson's day trip to St Ives while on that holiday and their encounter with

Winifred Nicholson **Seascape with a Dinghy** c.1928 Kettle's Yard, Cambridge. *Photograph: James Austin*

Opposite:
Artists' show day, St Ives, March 1935.
Tate Gallery Archive

Alfred Wallis is enshrined in Ben's famous account published soon after Wallis's death in 1943:

In August 1928 I went over for the day to St Ives with Kit Wood: this was an exciting day, for not only was it the first time I saw St Ives, but on the way back from Porthmeor Beach we passed an open door in Back Road West and through it saw some paintings of ships and houses on odd pieces of paper and cardboard nailed up all over the wall, with particularly large nails through the smallest ones. We knocked on the door and inside found Wallis, and the paintings we got from him then were the first he made.

Probably the single most important event in St Ives in the 1920s was, however, the decision by Bernard Leach to establish a pottery there. Leach had trained as a painter and printmaker but saw his life's work revealed when he discovered and came to understand Japanese ceramics while living in Japan from 1909 to 1920. Returning to Britain, he set about promoting the Japanese ceramic tradition, and reviving the English tradition of slipware. A wealthy patron influenced him to do so in St Ives which, it has often been remarked, could not have been a worse place to locate a pottery, owing to lack of raw materials and customers. However, working with his friend and associate Shoji Hamada, and a growing number of apprentice assistants, Leach had, by the late 1920s, established a working base and some audience for the Leach Pottery's dramatically beautiful ceramics. The pottery was also to play a continuing part in bringing together different strands in the local community. Leach, for example, was one of the founder members of the St Ives Society of Artists in 1927; others included Moffat Lindner, John Park, and George Bradshaw. The

society promoted artistic activity, and organised exhibitions in the largest Porthmeor studio from 1928, staging open days and sustaining a high profile for painting in the town.

At the same time St Ives became the location for remarkable developments in craft-based design and production. The firm of Crysede, producing hand-printed silk and linen was founded in Newlyn in 1920 by Alec Walker. He came from a Yorkshire family of mill owners and silk manufacturers, and came to Newlyn to concentrate on his own designs. In 1925 Alec Walker persuaded a friend from Yorkshire, Tom Heron to join him in running Crysede. They shared a belief in William Morris's ideals, and Heron's flair for management combined with Walker's designs ensured success. Heron persuaded Walker to expand, and in 1926 they moved the factory to an old pilchard cellar on the Island in St Ives. The progress of Crysede did not last, and in 1930 Tom Heron and family moved to Welwyn Garden City where he continued his work in his own firm of Cresta silks.

During their active partnership Walker and Heron brought in architect Wells Coates to design their shops and Edward McKnight Kauffer to design the note-paper. In St Ives skilled craftsmen and women worked in the dyeing of silk, the 'chemistry' of printing, the carving of woodblocks, the printing of silk and making up garments. Both Alec Walker and Tom Heron had a wide interest and involvement with the arts. Alec Walker travelled and knew Zadkine in Paris, while Tom Heron had been a leading protagonist of the Leeds Arts Club. For Patrick (born in 1920) Tom Heron's son, these early years in Cornwall had a profound influence, and lasting family

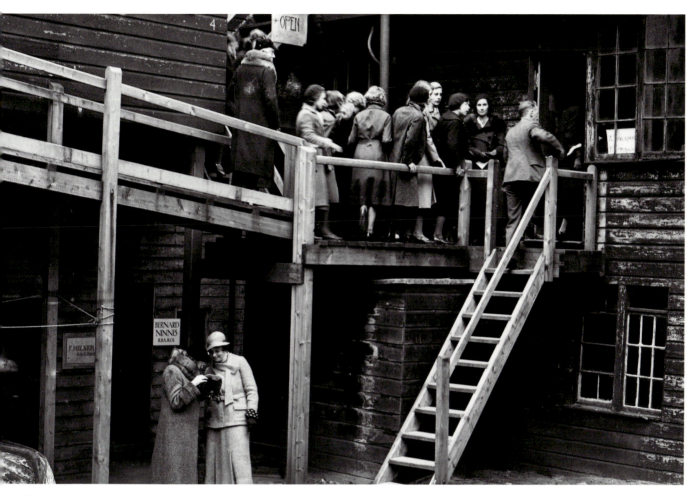

riendships were made with Bernard
Leach and with the young Peter Lanyon.

For many in St Ives outside the circles
of the modern artists who admired him,
Alfred Wallis's situation seemed at once
laughable and tragic. It seemed that the
artists and patrons whom Nicholson
introduced to Wallis's work — if not
always to the man himself — were
onising a figure who, increasingly
eccentric, withdrew further and further
from normal social life. Only his activity
s a painter seemed coherent. Yet to
yes accustomed to the accomplished
traditional landscapes of the painters
who dominated the St Ives Society of
artists, his painting appeared childlike,
rude and incompetent. But it was pre-
isely these qualities of Wallis's work
hat Nicholson and his circle so admired.
Wallis confirmed their feeling that there
must be more — or less — to art than
he repetition of traditional subjects in

traditional ways. They also felt that the
desire to make important art had to come
from within, untouched by motives of
worldly success. Wallis lacked education
and painted, as he said, simply to keep
himself company. In Nicholson's words,
each picture was 'an event', a fusion of
memory and formal arrangement.

Bernard Leach similarly questioned
established traditions, looking back to
pre-industrial English country pottery
and seeking to combine its qualities
with the ideals and standards of the best
Eastern ceramics. He thus hoped to
bridge through art the differing philoso-
phies of West and East. His Japanese
colleagues were also seeking to rediscover
a pure approach to a vernacular idiom
that had been lost. The act of taking a
piece of clay, moulding it into the sim-
plest of forms, and dipping it by hand
into a glaze before firing, resulted in
objects that satisfied both the eye and the

hand, as well as having an everyday use.

In the 1920s some writers on modern
art sought to make a connection with
cultures untainted by the European post-
Renaissance tradition, which had reached
its apotheosis in the Victorian and
Edwardian eras. Pre-Renaissance artists
such as Duccio and Giotto, referred to
by the Victorians as the Italian
Primitives, came to be admired,
together with non-Western artists and
Western artists without formal training,
so-called naive or primitive artists. The
new interest in such art, Nicholson said,
was part of a search to go back to
something with solid foundations at a
time of economic and political turmoil
in the aftermath of the First World War.
'One was wanting to get right back to
the beginning and then take one step
forward at a time on a firm basis.'

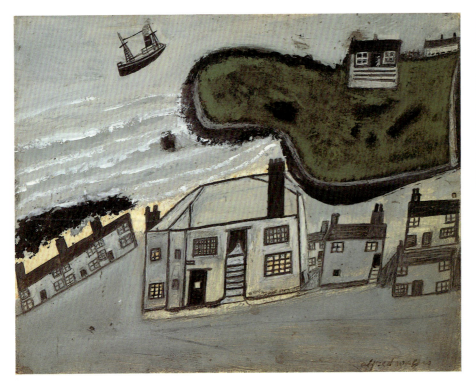

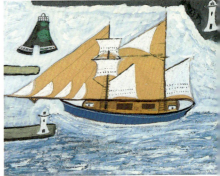

Alfred Wallis *1855-1942*

The Blue Ship (?c.1934)

Oil on board

43.8 x 55.9 (17 1/4 x 22)

Presented by H.S. Ede 1959

T00291

Alfred Wallis *1855-1942*

'The Hold House Port Mear Square Island Port Mear Beach' (?c.1932)

Oil on paper

30.5 x 38.7 (12 x 15 1/4)

Presented by Dame Barbara Hepworth 1968

T01087

Wallis's pictures in the Tate collection vividly illustrate his working methods. Wallis usually painted on old pieces of card. These were often irregular in shape: if they were not he occasionally cut them himself. He then painted his picture taking account of the shape of the card.

His titles generally describe the subject: 'The Hold House port mear square island port mear beach' is the title as it is written in Wallis's hand on the reverse of the card, although as its former owner Barbara Hepworth remarked, 'this does not mean much to us'. She explained in a letter to the Tate that this is a picture of the strangely shaped old house on the corner of Porthmeor Square and Back Road West, opposite Wallis's front door.

Wallis repeatedly painted this house, imagining different views above, behind and around it in the twisted streets of the Downalong area of St Ives. This is a clue to the nature of his appeal to the young modern artists who so admired him. His paintings are rooted in day-to-day reality, the streets around his home. This reality was confronted imaginatively each time he addressed, with fresh colours, a new, differently shaped board. The same street or row of houses can feel different on different days. Wallis used his imagination to project this feeling into each fresh image of the same place.

In 'The Hold House' the green island overlooking the end of the town swells out into the picture space, looming large, as when on a clear day, a distant view suddenly seems nearer. Porthmeor Beach is depicted as a thin strand behind the houses. Wallis conveys how, when we stand a few yards away in Porthmeor Square with the beach out of sight, the sea's roar can be heard, a constant reminder of its presence.

Wallis would remark that 'most of what I do is out of my memory, of what used to be'. In his image of 'the big ship' he travels across the Penwith peninsula to Mounts Bay. The disparity in scale between the small castellated peak of St Michael's Mount and the huge schooner suggests the recollections of a sailor; the massive rigging of his ship and the vastness of the ocean make all else shrink by comparison.

Like the picture of Porthmeor Square, this work was presented to the Tate by one of Wallis's admirers, in this case H.S. Ede. Ede later opened his home, Kettle's Yard, in Cambridge, as a place where his collection of modern art, including an outstanding collection of work by Wallis, could be enjoyed in a domestic setting.

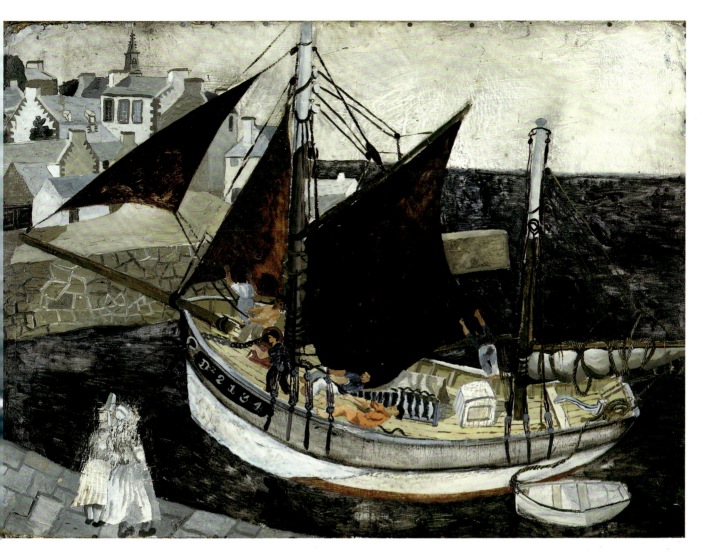

Christopher Wood *1901-1930*
Boat in Harbour, Brittany 1929

Oil on board
79.4 x 108.6 (31 1/4 x 42 3/4)
Presented by Mrs Lucy Carrington Wertheim 1962
T00489

After his friends the Nicholsons had left Cornwall in 1928, Christopher Wood stayed on in St Ives. He loved the starkness that was revealed when the summer visitors had gone. He wrote to Winifred Nicholson: 'The hills are straight and hard and on the top are windswept trees and telegraph poles. St Ives is on the edge of Europe and the first English rebuff to those coming from distant parts.'

'Boat in Harbour' was painted the

following year. In between Wood had spent a winter in Paris. Having done virtually no work there, he travelled to Brittany in an attempt to recapture the spirit he had experienced in St Ives. He found the atmosphere strikingly reminiscent of Cornwall, and wrote to Winifred Nicholson: 'I wanted to to see the French crab boats we saw at Falmouth and St Ives so much . . . I looked everywhere for them and found none and was very disappointed for I came here for that reason. But yesterday I went across to St Servan It is quiet, up a creek like St Mawes, and as we came round the corner there I saw about six of these lovely boats, lying quietly there being washed and refitted by their sailors in their red brown overalls.'

The crab boats were a signal that he had

found a comfortable, familiar place. He decided to stay, and found somewhere to work in Douarnenez, where he probably painted this work. The flat arrangement of the painting and its careful juxtaposition of blues, browns, reds and greys are clear examples of the lessons he had learned from Wallis. The Breton women, the church spire, and the boat's registration letters, are clues that distinguish the scene from a Cornish one, and the tone of the picture is melancholic as well as affectionate. Wood wrote to Ben Nicholson, 'The place is very like St Ives. In fact everything here looks like Cornwall which makes me want to be back there again with you. If only I could have last summer just as it was I would be very glad.'

Earthenware with decoration in coloured slips under a
yellow glaze
46 (18 ¹/₈) diameter
Wingfield Digby collection

Bernard Leach and his friend and associate
the Japanese potter Shoji Hamada settled
in St Ives in 1920. There they founded a
pottery and built a three-chambered
climbing kiln, the traditional Far Eastern
kiln. It was the first such kiln in the West.
This experiment was the result of Leach's
experience in Japan, where potters such as
Hamada were seeking to re-establish the
indigenous Japanese ceramic tradition.

This dish is an example of Leach's work
in traditional English slipware, and it shows
how in his early career he used Eastern
traditions to rebuild native English ones.

It is large and heavy. The image of a
griffon in its centre is probably derived
from heraldry, but also recalls traditional
Chinese or Japanese painting. The browns
and reds of its colouring are signs of its
earthy sources, but the flamboyance and
brilliance of the way the decoration is
applied reveal Leach's skills as a natural
draughtsman. These fused elements of his
technique echo his philosophy of bringing
East and West together.

This dish also brings into focus something
that is often remarked upon when we are
enjoying Leach's best ceramics. Unlike much
pottery made by leading figures in the
studio pottery movement of the twentieth
century, Leach's work, however stunning in
its visual and physical impact, always retains
its potential as a functional object.

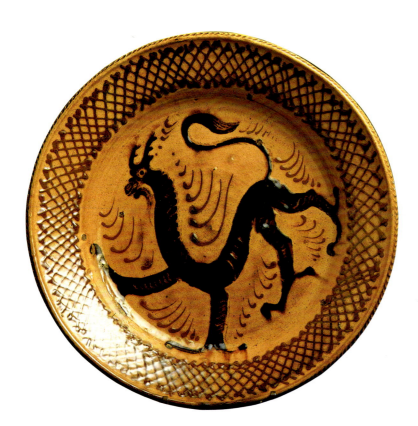

Ben Nicholson OM *1894-1982*
Porthmeor Beach 1928

Oil and pencil on canvas
90 × 120 (35 1/2 × 47 1/4)
Private collection

Nicholson commented on coming to terms with Wallis's work in a letter to the Tate Gallery in 1962. 'I was (in quite a different way to Wood) influenced by Wallis's ptgs: they were approached by him not as "design" but as actual events and were a basic idea like Lascaux is a basic idea. One finds the influences one is looking for and I was certainly looking for that one.'

The Tate Gallery does not own any works from Nicholson's first visit to Cornwall. The work illustrated here was in the Helen Sutherland Collection and is now on loan from a private collection. It shows how Nicholson related to Wallis's evocative colours and to his uncanny ability to set an element of the story of the painting – a ship passing a rocky point, say – in a critical compositional role. Equally, this painting shows how Nicholson's sophistication cannot easily be shaken off. The enigmatic architectural feature to the right of the work opens out the depth of the painting, creating an uneasy space which is suggestive of traditional perspective.

Cornwall and British Modernism in the 1930s

West Cornwall continued to attract artists who wanted to work quietly, or study. William Scott began a long association with Cornwall when he worked in Mousehole in 1936, whilst Stanley Spencer visited once, spending six weeks in St Ives in 1937. The art schools run in the colonies encouraged this process, attracting, for example, Adrian Heath to work in Newlyn in the summer of 1939. Local people were best placed to take up this opportunity. The young Peter Lanyon studied at Penzance School of Art, in 1936-7, as well as with Borlase Smart and at the St Ives School of Painting, which was started by Leonard Fuller in 1939. In 1937 Lanyon met the writer and painter Adrian Stokes, a visitor to Cornwall. In 1938 Stokes decided to move to St Ives with his first wife, the artist Margaret Mellis.

In Stokes's most widely read book *Colour and Form* (1937), he discusses the tactile presence of forms in our psyche. He suggests that an aesthetic response to the world is possible for everyone regardless of education. As an example, he cited Wallis's entirely natural depictions of sea and rocks. This reference to Wallis shows how aspects of modernist art and thought in the 1930s could provide a framework for understanding the remote places of Britain, as seen from the metropolitan centre. In Paul Nash's depictions of standing stones, specific places are imaginatively transformed. His 'Nocturnal Landscape' (Manchester City Art Gallery) represents Men-an-Tol in the Penwith peninsula, between St Ives and Land's End, and is probably based on a photograph. The correspondences between the forms depicted in the Tate Gallery's 'Equivalents for the Megaliths', by Nash, and the forms of Barbara Hepworth's sculpture at that time, vividly illustrate a common aim to bring together the psychological content of Surrealism and the purity of constructive abstract art. They help to explain why, when the time came to consider living and working outside London, the 'sense of place' projected by an area like West Penwith could attract an artist who had never previously been there.

After the chance meeting with Alfred Wallis, Nicholson returned only once to Cornwall before 1939. Wood, after staying on in St Ives in 1928, was, tragically, never to return. He spent time in Brittany, frequently remarking in letters on how much it reminded him of Cornwall. He may have been on his way there when he was killed by a train in 1930. Soon after this the Nicholson's

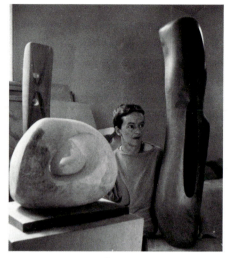

marriage came under strain. By 1931 Ben Nicholson had met Barbara Hepworth and by 1932 was living and working alongside her in London.

Hepworth had studied in Leeds, London and Rome. With her first husband John Skeaping and her friend from Yorkshire Henry Moore, she was developing a vocabulary of pure, simplified forms in her sculpture. The direction of Nicholson's work was similar. From their studios in Hampstead, Nicholson, Hepworth and Moore were in touch with many of the leading European practitioners of the new abstract art. Under the particular influence of Piet Mondrian, Constantin Brancusi, Jean Arp and Jean Hélion, all of whom they met in Paris, Nicholson and Hepworth's work became increasingly abstract. Two important publications, first that accompanying the exhibition *Unit One* in 1934, followed by *Circle* in 1937, established their work at the centre of British modern art.

Throughout this time Nicholson and Hepworth were reminded of St Ives by amongst other things Alfred Wallis's paintings. In a photograph of Nicholson's studio taken by Hepworth in 1933, we can see a Wallis – which Nicholson was later to present to the Tate – next to works by Nicholson which prefigure the completely abstract reliefs he began to make a few years later. The lessons that Wallis's work held for Nicholson, their realisation of an idea through an intuitively 'right' form and colour, and their appearance almost as relief objects, are strikingly affirmed.

In London in the 1930s Wallis's work was collected by many artists and writers in modernist circles. Collectors included Hampstead based critics and curators such as Herbert Read, Adrian Stokes and H.S. Ede. Hepworth herself acquired her first Wallis in 1932 or 1933, long before she visited St Ives. Wallis's work began to appear in the literature of modern art, notably Read's *Art Now,* alongside other naive or 'primitive' artists, as part of the discussion of the general importance of this art to modernism.

The importance of place was nevertheless suppressed in the published views of Nicholson and Hepworth at this time. After the experience of taking part in *Unit One* and other group projects, Nicholson joined with the architect Leslie Martin, and the sculptor Naum Gabo, who had recently arrived in London from Europe. Together they sought to give a clearer statement of ideals. The result was a book, *Circle,* subtitled *International Survey of Constructive Art,* published in 1937. *Circle* emphasised the democratic, utopian social aspect of abstraction, as well as its universal character, transcending national differences. These qualities took on urgent relevance as Europe lurched towards war, as fascism placed an importance on national and racial identity.

Above left:
Barbara Hepworth in Trewyn studio
in 1952

Above:
Paul Nash **Nocturnal Landscape**
1938 *Manchester City Art Gallery*

Dame Barbara Hepworth *1903-1975*
Three Forms 1934

Stone

25.7 x 47 x 21.6 (10 1/8 x 18 1/2 x 8 1/2)

Presented by the executors of the artist's estate 1980

T03131

'Three Forms' exemplifies the way in which the modernist goal of 'truth to materials' led to a refinement and simplification of the forms of carved sculpture. In the 1930s, Hepworth, and her friend and contemporary Henry Moore, explored the nature of carving in stone or wood. They came to understand that carving was a form of dialogue between the hands and tools of the artist and the natural grain and structure of the material. Working with a regular rhythmic swing of hammer on chisel, Hepworth and Moore ensured that the stone or wood assumed only the forms which its own material properties allowed.

In this way the sculpture emerges naturally as a satisfying shape.

In 1934-5, when she was living in London, Hepworth made a number of works where simple separate forms are placed on a base which defines the space in which they sit. The stone in this work is grey alabaster, and its dramatic veining both unifies the elements and gives each one a distinctive character. The sculpture is now usually displayed in the Barbara Hepworth Museum in St Ives. There it suggests how the natural forms discovered by the artist in her London studio led her to relate to natural forms in the Cornish landscape.

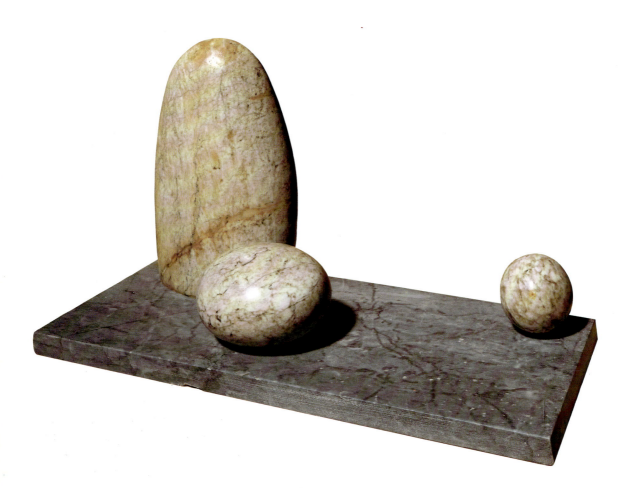

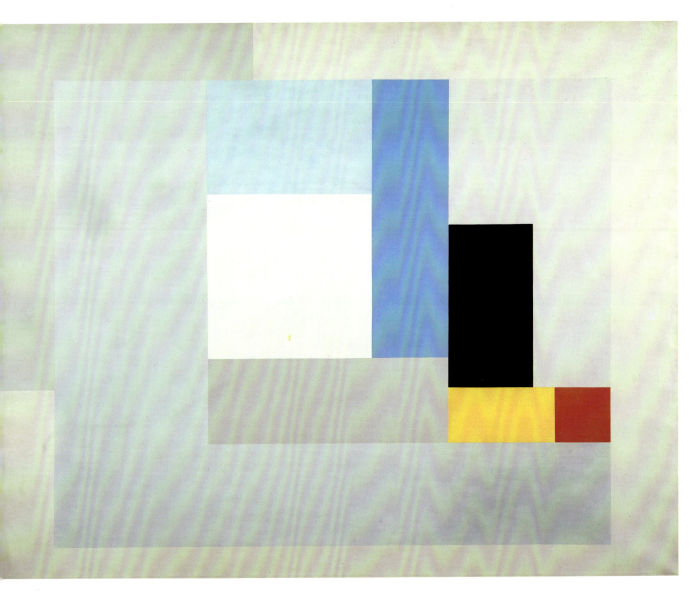

en Nicholson OM *1894-1982*
ainting 1937 1937

Oil on canvas
59.4 x 201.3 (62 ³/4 x 79 ¹/4)
urchased 1955
00050

Nicholson painted this work in the same year that *Circle: International Survey of Constructive Art* was published. Nicholson was one of the editors of *Circle,* which promoted abstract art and aimed also to establish relationships between painting and sculpture, and architecture and design. The scale of this painting, not apparent in reproduction, is that of a mural and this, combined with its bold desposition of rectangular forms gives it a monumental, architectural, quality.

Nicholson's colour scheme is confined to the primary colours, red, yellow and blue, and the non-colours black, white and grey. He has also confined himself to rectangular forms arranged strictly on horizontal and vertical axes. He is thus making an extremely pure painting in which the key elements of colour, form and line are used only in their most basic, irreducible forms.

However, the blues and greys are deployed in an extremely subtle range and the painting is also intensely luminous. The effect is highly poetic, suggesting that even in this austere composition we are seeing an example of Nicholson's lifelong response to light as experienced in landscape from the Alps to St Ives. It is also possible that the arrangement of the elements of the composition has its origins in his earlier painting of simple objects on a rectangular table top.

The War Years

During the Second World War several different groups of artists associated with St Ives came together. In the 1930s the town had continued to attract artists as students, visitors and residents. The backbone of the resident community was formed by older artists such as Borlase Smart and Moffat Lindner, and more recent arrivals such as John Park, Leonard Fuller, and his wife Marjorie Mostyn. With the addition of younger acolytes such as Peter Lanyon, and the community around the Leach Pottery, a picture emerges of a diverse range of artists pursuing their different interests. They were joined by a new group who left London to escape the impending war. These were Ben Nicholson and Barbara Hepworth, followed by their friends Naum and Miriam Gabo. Their move was prompted by an invitation from Adrian Stokes and Margaret Mellis.

Many of Nicholson and Hepworth's circle in London had also chosen to leave. Some, like Mondrian, who at the last minute went to New York, were leaving Britain for good. Others stayed,

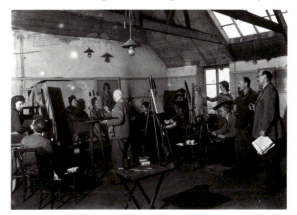

but throughout the war friends from London visited the artists in Cornwall, either to test living conditions away from the rigours of the wartime capital, or simply to stay in touch in difficult times. They included J.D. Bernal, Margaret Gardiner, H.S. Ede, Herbert Read, and many others. In St Ives they found a community of people who, while apparently removed from the war were nevertheless feeling its impact.

Alfred Wallis was by now clinging to his sanity, and his letters provide a moving testimony to the insidious darkness of this time: 'every thing seemes to be in a on settled state, natan against natan it seems all over the world … Ihop it will soon com to a proper peace' [*sic*]. Wallis died in 1943, in Madron Workhouse, near Penzance. He was remembered a few months later in articles by Sven Berlin, who had recently moved to St Ives, and Ben Nicholson, published in *Horizon* magazine. There is a more permanent memorial to Wallis in Barnoon cemetery. Bernard Leach made and decorated the tiles on Wallis's grave. Leach used the image of Godrevy lighthouse, seeing Wallis's images of the light as symbols of his faith, rooted in the Salvation Army tradition.

Leach was, like Stokes, Smart and the young Denis Mitchell, a member of the Home Guard. He was able to persuade the authorities to release to him a group of conscientious objectors to work in the pottery. One of them was Patrick Heron, who until then had been digging ditches. The Leach Pottery had been improved

before war broke out, and struggled, successfully as it turned out, to maintain production. Contacts with new residents in the area brought new artistic friendships, notably between Leach and Gabo.

Many of these friendships extended across the various artistic boundaries in St Ives. For example, Wilhelmina Barns-Graham, a college friend of Margaret Mellis from Edinburgh, arrived in St Ives in 1940. She soon met Borlase Smart, who was prominent in the St Ives Society of Artists and occupied one of the Porthmeor studios in Back Road West. Smart asked Barns-Graham to introduce him to the modern artists, and resolved to encourage them to become more involved in local activities.

During the war, Nicholson, Hepworth and Gabo made predominantly small-scale work, due largely to lack of facilities, space and materials. For Hepworth childcare was a dominant preoccupation when she first moved to the area. At first working in a confined space in snatched time, then gradually finding more time and room once she and

Nicholson found their own home, she slowly assimilated her new surroundings. The writing of Adrian Stokes, with its speculations on the relationship between the human body, solid forms, and the surrounding space of the landscape, was important to her as she tried to resolve similar issues in her own work.

The presence of Gabo was of great importance, stimulating ambition and raising the awareness of art beyond St Ives. His work and ideas provided a direct link to the heart of European and international modernism, crucially restating the validity of abstraction at a critical moment.

St Ives art from this period reflects the wartime mood of introspection and reassessment, and the prevailing limited means. Nevertheless, some of it possesses great intensity. The influence of the Cornish landscape and the presence of the human figure were fundamental, but at the same time the positive value of working in a modernist way was confirmed for many artists.

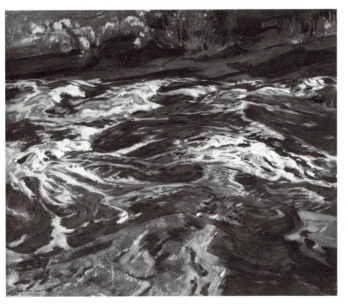

Left:

Borlase Smart **Seascape** *c.*1938
Cornwall County Council Art for Schools
Collection

Right:

Grave cover of painted stoneware tiles
for Alfred Wallis, in St Ives old
cemetery: made by Bernard Leach in
1942. Photograph: Edwin Mullins

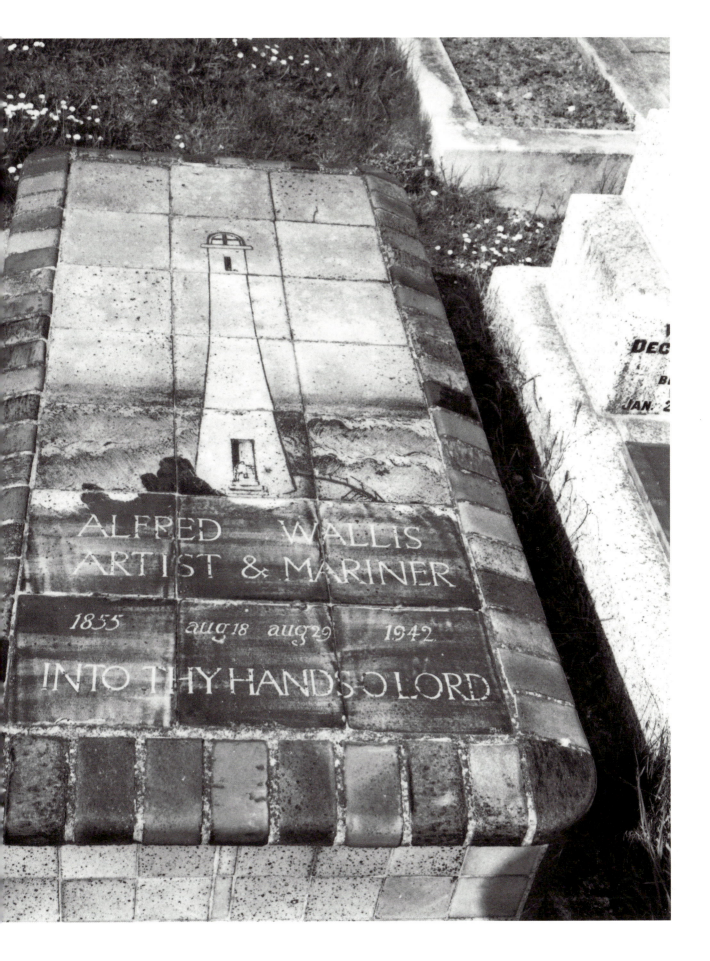

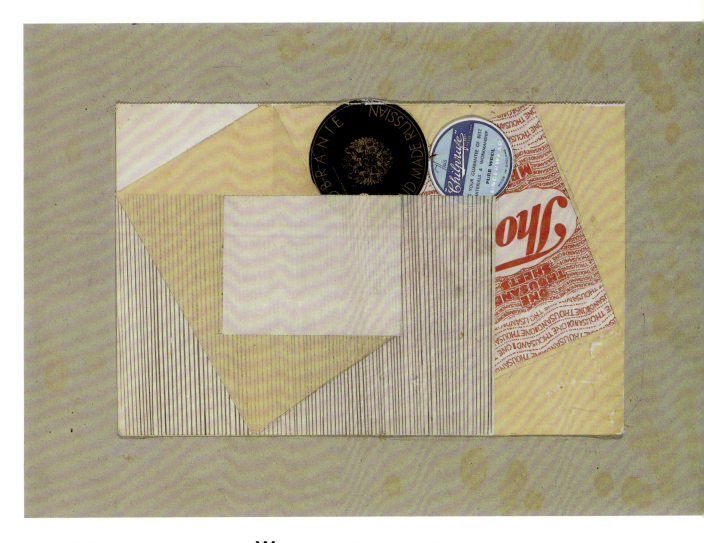

Margaret Mellis *born 1914*
Sobranie Collage 1942
Collage of board and paper
26.3 x 37 (10 ³/₈ x 14 ¹/₂)
Purchased 1985
T04124

When Nicholson, Hepworth and Gabo arrived in St Ives just before the outbreak of war in 1939, Margaret Mellis was painting what she later described as 'large white still lifes' in a constructive manner influenced by Nicholson. She wanted, however, to put back colour and texture into her work. At Nicholson's suggestion, she experimented with collage as a way of creating abstract forms that would have strong surface qualities.

The paper labels were used purely for their formal properties: for example where words appeared, they were arranged upside down, so that the lettering read only as graphic marks. This work gets its title from the circular top from a Sobranie cigarette tin. Mellis's use of textured papers

and wrappings immediately recalls the classic early collages of Picasso and Braque However, the main handmade elements of the work, the lines across the largest piece of paper, echo the way Juan Gris, another pioneer of collage, added to the illusionism of his work by drawing in texture.

A curiosity of this work is the fact that on the reverse is an unused handmade poster for a campaign that Hepworth, Nicholson, Gabo, Mellis and others mounted in St Ives in 1942. The campaign was to buy equipment to assist the Soviet Union, which had joined the war the previous year. In a bold hand, probably Gabo's, are the words 'help this town buy X-ray unit for Russia'.

Naum Gabo *1890-1977*
Spiral Theme 1941
Cellulose, Acetate and Perspex
14 x 24.4 x 24.4 (5 1/2 x 9 5/8 x 9 5/8)
Purchased 1958
T000190

Gabo had moved around Europe for much of his life, and was obviously deeply affected by the idea of war in Europe and dreaded the prospect of invasion. He wrote in his St Ives diaries 'Meanwhile one looks at the sea (for the past few days it has been especially calm, especially blue and especially endearing). It lies stark naked between my window and the horizon and captivates one by its simplicity. The heart suffers looking at it and the contrast with what is happening in the world. One looks and thinks how many more days or weeks will this peace last on this little plot of land?'

When Gabo moved to St Ives in 1939 his work became smaller in scale, though he persevered in the pursuit of pure form and use of modern materials that had been his practice for two decades. In the late 1930s he had met a manager at ICI, Dr John Sisson, who was able to guide him to the best of the recently invented clear plastics. Gabo soon ran out of this material after moving to Cornwall. Thereafter he made drawings, and carved small pieces of stone. Eventually Sisson was able to provide more plastic which enabled the artist to

resume working, albeit on a small scale.

Made in 1941, 'Spiral Theme' shows a new openness in Gabo's work and an allusive quality, perhaps prompted by his feeling that the tide of the war was turning. Based on an idea from the mid-1930s, the work reveals the artist's new awareness of landscape. The Perspex has a physical presence which defines line and form, but is also weightless and insubstantial, like light moving across water. Two arching forms break over a gentle slope, a dynamic twisting spiral energising the centre.

In 1942 this and other works by Gabo were shown in an exhibition at the London Museum. The exhibition was extraordinarily successful, and 'Spiral Theme' was particularly popular. Gabo wrote: 'To my complete surprise this object has produced, what I would describe as a tremendous effect on the mass of visitors (there were about 10,000), as well as on the small number of critics from magazines and newspapers who have been impervious to my ideas until now. It is still a complete mystery and puzzle to me what precisely it is in this, my latest work, that has moved their hearts.'

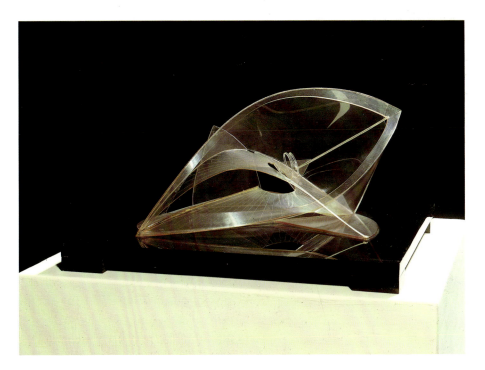

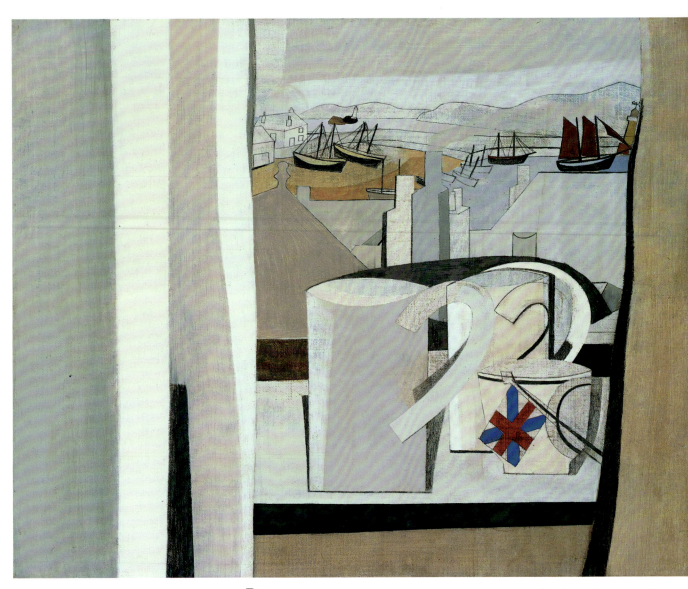

Ben Nicholson OM *1894-1982*
St Ives, Cornwall 1943-5

Oil on board

40.6 x 50.2 (16 x 19 3/4)

Purchased 1945

N05625

During the war Nicholson found it very difficult to work on the scale of the 1930s. Drawing became much more important to him. His natural sense of line and composition made itself felt in a rich body of drawings of the Penwith landscape, which he explored by bicycle. In his studio he returned to the still life on the table top which was the subject of his first mature work in the 1920s.

The result of this dialogue, between drawing in the landscape and study of objects in the studio, was a number of small paintings in which a still life was set before a window through which a view was permitted. This gave a double space in the picture. In the foreground, cups and jugs are laid in a flat plane, dominating the work. Within a smaller rectangle, a different scale is explored: tiny depictions of large objects, such as ships, buildings and so on, set out in a clear, open space.

This small painting remained in Nicholson's studio in St Ives for over two years. Then, on VJ day in 1945, he painted in the Union Jack, prompted by the celebratory flags which appeared in shops. The idiosyncrasies of this work always gave him doubts about its status, but it now seems a quietly positive painting which, while remaining in some ways a 'one-off' nevertheless anticipates the course that his post-war work was to take.

Dame Barbara Hepworth *1903-1975*
Landscape Sculpture 1944, cast 1961
Bronze
31.8 x 65.4 x 27.9 (12 1/2 x 25 3/4 x 11)
Presented by the artist 1967
T00954

This is the first work by Barbara Hepworth to which she gave a title referring directly to landscape. With such a general title, it was clearly not meant to evoke a specific sense of place. Instead it suggests a more general evocation of the physical experience of landscape.

The low, scooped-out form is designed to be seen from above. When it is viewed by a child, it spreads out sideways at their eye level. The hollowed centre, perhaps prompting thoughts of a valley, is only revealed by moving round the work. Glimpses through this space are permitted by two holes, which give a geological structure to the whole form.

Two stringed planes which radiate from two viewpoints within the space, not only suggest the experience of space within the form, but also evoke a whole range of imagery to do with the body as much as the landscape: sinews, nerves, lines of sight. These stringed elements, reminiscent of Gabo's use of stringed passages to articulate space within a sculpture, also deny access to the space of the sculpture, creating a strange tension.

This work exists in two versions. The original elmwood carving of 1944, is on permanent loan to the Barbara Hepworth Museum. The one illustrated is a bronze cast made in 1961.

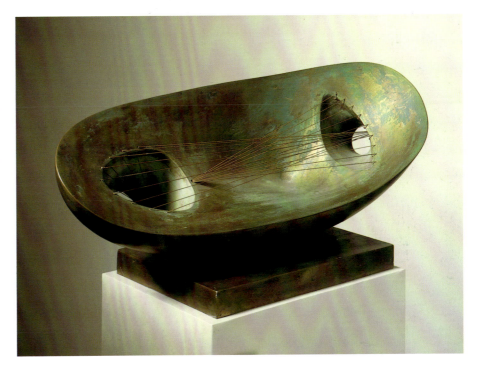

A New Force for Abstract Art

Left:

Wilhelmina Barns-Graham

Glacier Crystal, Grindelwald

(detail) see page 47

Right:

Sven Berlin, St Ives 1947

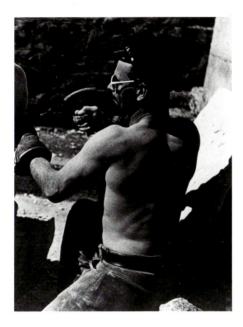

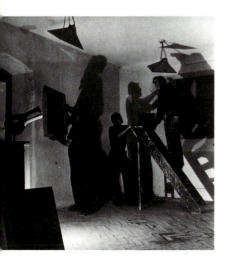

Left to right: Sven Berlin, John Wells
and Peter Lanyon prior to the opening
of the first Crypt Exhibition 1946.
Photograph: *Illustrated* 5 October 1946.
Collection Sheila Lanyon. *Tate Gallery
Archive*

The period following the war, up to about 1956, is often characterised as the most dynamic and cohesive era in the development of modern art in St Ives. It has been much written about and discussed. However, some accounts focus on personalities as much as the art produced. This is perhaps due to the fact that some issues generated great depth of feeling, in particular, that of accepting abstract art.

From around 1943, the St Ives Society of Artists, at Borlase Smart's instigation, sought to embrace the work of the modern artists, including Hepworth and Nicholson. However, they and the younger artists soon felt that their work was marginalised by the way it was presented in the society's exhibitions in the old Mariners' Church – in a corner behind the font. As a result some artists began to organise separate displays of their work, most significantly in the crypt of the Mariner's Church itself. In 1947 seventeen artists showed there, followed by a further exhibition by four of their number, Sven Berlin, Lanyon, Wells, Barns-Graham, and the printer Guido Morris.

The death of Borlase Smart later that year probably marked the end of any attempt to integrate the modern artists' work with the more traditional work of the Society of Artists. At the time, this was confirmed in the minds of many by the election as President of the Society, of Sir Alfred Munnings, whose vehemently anti-modern views were well known.

In 1948 a third Crypt exhibition
included the four artists of the second
show plus Bryan Wynter, David
Haughton, Patrick Heron, Adrian Ryan
and Kit Barker. This confirmed a common
thread in the work of this confident
group of artists. In the same year they
and ten others were the founder members
of the Penwith Society of Arts. The
Penwith established a separate identity,
distinct from the Society of Artists, for
modern artists working in the area.
However, to some it soon appeared to
be evolving in too dogmatic a way,
pushed by Nicholson and Hepworth into
becoming a rigid group promoting
abstract art. For example, a proposal
that there be separate sections for
abstract, traditional, and craft work, to
ensure access for those working in each
of those areas, led to arguments about
the relative importance of abstraction.
Peter Lanyon's complaints about some of
the artists stemmed from his unease over
their interest in Cornish issues as well as
his feeling for greater plurality. How-
ever, Lanyon was one of the first post-
war artists to understand that a locally
based art could be both modern and
international.

During the 1930s and 1940s, many
British artists had become increasingly
preoccupied with an idiom of spiky,
melancholy imagery, often recalling
English Romantic landscape painting of
the first half of the nineteenth century,
particularly the early work of Samuel
Palmer. Bryan Wynter's early work
provides an example of how this genre
affected some younger artists. It is
characterised by drawings in inks and
colour washes, often of places on the
moors of West Penwith. These drawings
often included derelict buildings, and
were occasionally populated by threaten-
ing surreal-looking birds.

At the same time much of the teaching
in art schools in Britain in the late 1940s
was dominated by the approach of the
Euston Road School, which emphasised
accurate recording of the human figure,
and the urban landscape. Terry Frost
recalls confronting this problem when
he returned to art school after being a
prisoner of war. War service meant that
many artists were in the same situation.
Mature and fired with energy, they were
prepared to take a fresh, less respectful
approach to the prevailing teaching
methods.

In this context, abstract art had to
re-establish itself after a period of
retreat. Victor Pasmore, for example,
has commented that 'in England, as in
France, the war had put the clock back,
and an almost reactionary situation
existed. Advances made in the 1930s
by Moore, Nicholson, Hepworth and
others had stopped in their tracks and a
totally provincial attitude prevailed.
After the war, therefore, my concern
was more with getting back on the rails
than with making new extensions.'

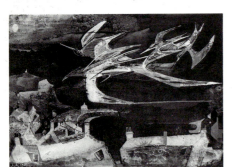

Bryan Wynter **Gulls Disturbing a
Town at Night** 1948 *Private collection*

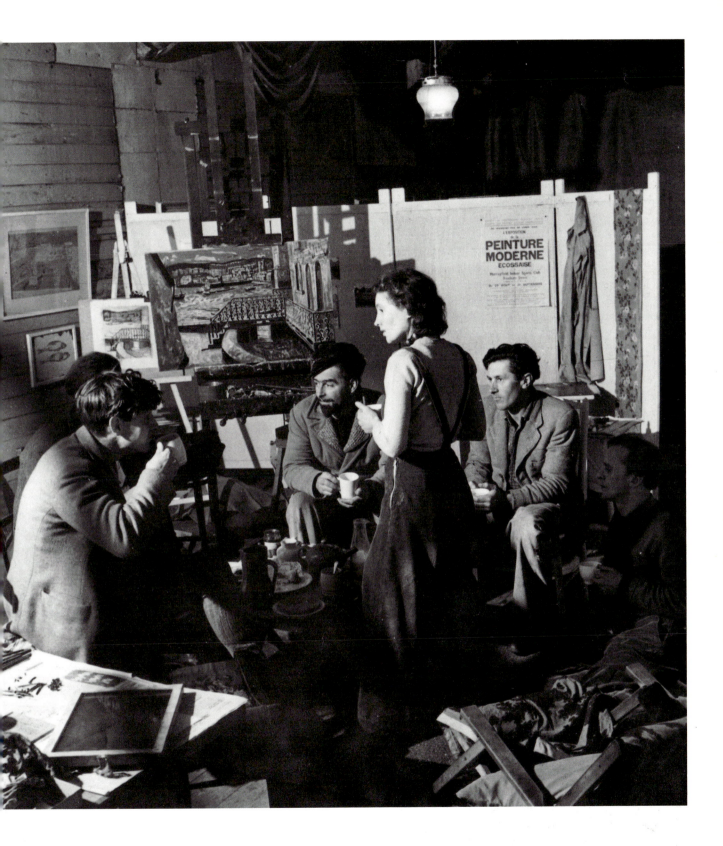

Dame Barbara Hepworth *1903-1975*
Fenestration of the Ear (The Hammer) 1948

Oil and pencil on board

38.4 x 27 (15 1/8 x 10 5/8)

Purchased 1976

T02098

In 1947 and 1948 Barbara Hepworth made a series of drawings of hospital operations. This is one of a group of six depicting a delicate operation, now no longer performed, to cut a window (a fenestration) in the inner ear. Hepworth was brought into contact with hospitals by the childhood illness of her daughter Sarah. This led to her being invited to watch an operation. The artist later recalled: 'When ... a suggestion was made to me that I might watch an operation in a hospital, I expected that I should dislike it; but from the moment when I entered the operating theatre I became completely absorbed by two things: first, the extraordinary beauty of purpose and co-ordination between human beings all dedicated to the saving of human life, and the way that unity of idea and purpose dictated a perfection of concentration, movement and gesture; and secondly by the way this special grace (grace of mind and body) induced a spontaneous space composition, an articulated and animated kind of abstract sculpture very close to what I had been seeking in my own work.'

She clearly empathised with the way in which the concentration of the surgeon's team was focused on the relationship between hand and eye. In this drawing there is a strong sense of rhythm in the arrangement of the hands and heads of the surgeons around the site of the operation. At the same time, all eyes focus on the delicate moment when a hammer pierces the bone around the inner ear to restore its fenestration.

In the dedication of the surgeons to their task, Hepworth saw a parallel to her own vocation as an artist: 'we forget, or we have no time in which to remember, that grace of living can only come out of some kind of training or dedication, and that to produce a culture we have to understand all the attributes of a proper co-ordination between hand and spirit in our daily life.'

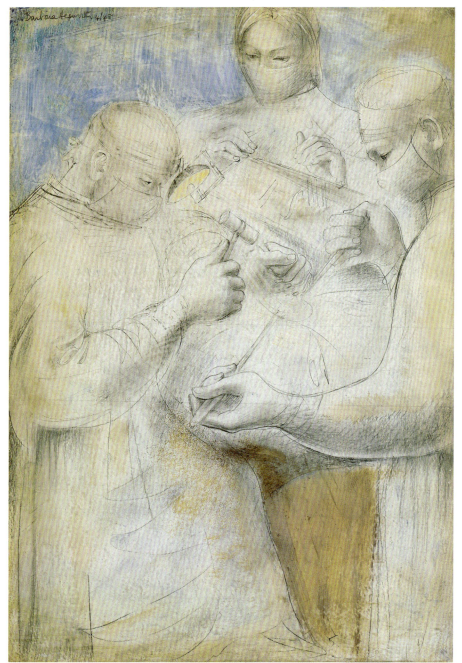

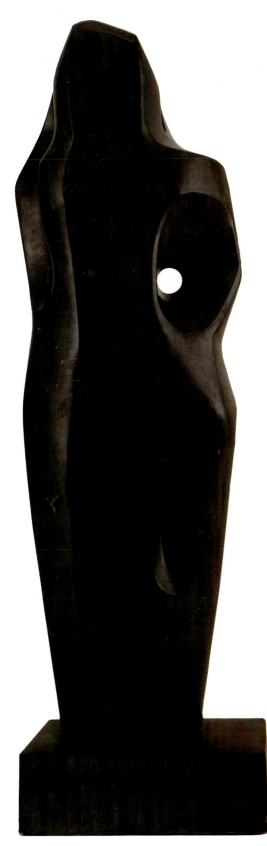

Dame Barbara Hepworth *1903-1975*
Bicentric Form 1949

Stone

158.7 x 48.3 x 31.1 (62 ¹/₂ x 19 x 12 ¹/₄)

Purchased 1950

N05932

In 1947-9, as well as making the hospital drawings, which number well over a hundred, Barbara Hepworth also drew models standing, and occasionally seated, in the studio. This practice continued into the early 1950s. Thus there are more drawings from this period than from Hepworth's entire mature career. This drawing activity was part of a search for a new balance of complexity and simplicity which she was seeking in her work.

In her sculpture this led her away from a clear single form, which had been her central preoccupation for the previous decade. She began to make more complex forms combining varied sculptural elements.

She cited 'Bicentric Form' as an example of how she sought a complex elision of different forms and figures within one single object. The work can suggest a single figure turning in space. We can discern what appear to be shoulders or limbs supporting a very obvious head. However, as we move around the sculpture it is possible to sense the artist's intention to suggest two figures on different centres of gravity, hence the idea of a 'bicentric' form. This is particularly noticeable when the planes of the head, which suggest faces, are out of the immediate line of sight.

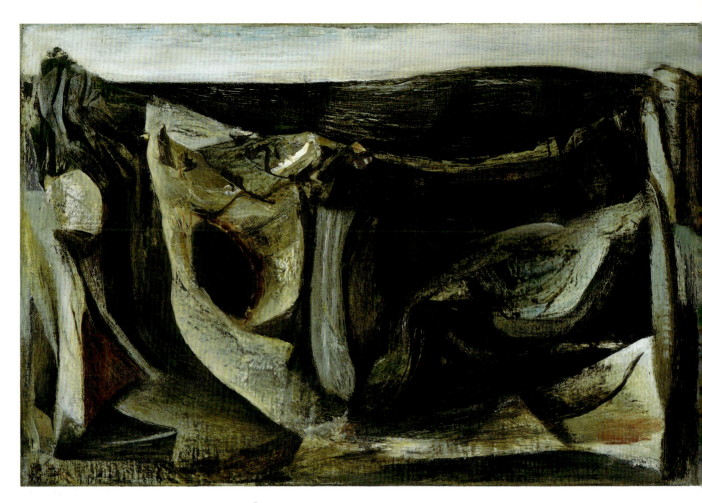

Peter Lanyon *1918-1964*
Headland 1948
Oil on canvas
51.5 x 77 (20 1/4 x 30 1/4)
Purchased with assistance from the Friends of the Tate
Gallery 1992
T06466

In the late 1940s Lanyon and some of his contemporaries, notably John Wells, were coming to terms with the work of older artists like Gabo, Hepworth and Nicholson. They had learned the value of a strong formal structure and controlled range of colours, but were keen to find ways of infusing these with their own personal experience.

'Headland' is a generalised image which evolved from Lanyon's interest in experience of a particular place. It perhaps attempts to communicate the relationship of sea to land. The treatment of the land is an example of Lanyon's use of landscape as a metaphor for the human, particularly female, body.

He wrote in 1948, in a style which suggests free association: 'Standing on a cliff looking at water moving among rocks perhaps two hundred feet below, the water movement is seen as a whole as a figuration. The distance, vertically below, upsetting the traditional security of ground added to the sea movement at the end of a conic downward viewed space, presents a disturbance of equilibrium in the observer. A readjustment is necessary either by removal to solid ground or a fall towards the engulfing sea play. An alternative readjustment can occur in the observer when he realises that he is seeing an image of his own existence.'

Wilhelmina Barns-Graham *born 1912*

Glacier Crystal, Grindelwald 1950

il on canvas

.4 x 60.9 (20 ¹/4 x 24)

esented by the Contemporary Art Society 1964

0708

This intense and subtle painting is a good example of how Barns-Graham, in her work of this time, sought to capture the overall experience of landscape rather than to depict it in literal terms. She had first visited Grindelwald in 1948, for a holiday, but the impression made by the high glaciers, seen for the first time in 1950, prompted a body of work which continued for four years.

The artist has written a vivid account of the experience which fed the painting: 'The massive strength and size of the glaciers, the fantastic shapes, the contrast of solidarity and transparency, the many reflected colours in strong light, the warmth of the sun melting and changing the forms, in a few days a thinness could become a hole, a hole a cut-out shape loosing a side, a piece could disintegrate and fall off, breaking the silence with a sharp crack and its echoes . . . This likeness to glass and transparency, combined with solid rough ridges made me wish to combine in a work all angles at once, from above, through, and all round, as a bird flies, a total experience. Using a method of drawing sharp lines in oil, intersecting lines that could be seen from several experiences at one time. The colour used was fairly representational in the earlier paintings, of which Glacier Crystal is an example.'

Within the relatively small size of the painting, the massive scale implied by the icy forms can be felt. The artist wrote in the same account 'I made notes and drawings . . . on the spot or immediately afterwards in my room. Once while working against the evening light rapidly fading, I experienced a terrifying desire to roll myself down the mountainside. Calmly as I could I came down the wood steps cut into the ice, Grindelwald far below. I recalled this when working later on some of the themes, using small interlocking shapes with the larger to give a sense of scale.'

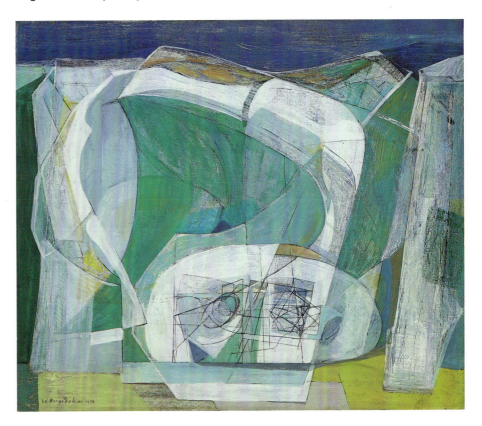

St Ives' Significance in Britain

In the late 1940s and early 1950s, Patrick Heron was working as a painter and an art critic. His writing shows how his interest in modern painting and sculpture evolved slowly from what was then an unorthodox admiration for Henri Matisse and Georges Braque. Artists such as Alan Davie and William Scott were aware of Abstract Expressionism, the new abstract art in America, while Roger Hilton, through friendships with European artists, was closely in tune with new painting in Continental Europe. Heron's writing in the first half of the 1950s were important in giving these artists a sense of direction, and in establishing international links for the new art in Britain. He selected an important exhibition in 1953, *Space in Colour,* which presented a group of artists all seeking ways of exploring the new forms of painting.

In its first decade the Penwith Society's members were part of the European avant-garde. While artists such as Denis Mitchell, Wilhelmina Barns-Graham and many others concentrated their efforts on making the Penwith Society work, their commitment to working in St Ives and West Cornwall did not mean that they lost touch with the world beyond. Indeed, this period saw the real establishment of St Ives and west Cornwall as an important modern art centre. In addition to painters, musicians, designers, architects and writers – notably W.S. Graham and the Canadian Norman Levine – began to visit or come to work in the area. Two key figures who settled in West Cornwall, Paul Feiler and Karl Weschke, were of German upbringing and after very different but equally difficult wartime experiences, found it a place to provide a secure and fruitful working environment. Conversely, some artists who played a critical role in the evolution of modern art in St Ives were never really resident in the town. Painters such as Scott or Adrian Heath, Davie or Hilton kept in close contact with each other and the town, yet other artists, such as Victor Pasmore or William Gear only visited a few times, but from that created an important body of work.

At the time a fledgling Arts Council was seeking to encourage activity away from the capital by funding art galleries, as well as theatres and concert halls. Thanks to the Arts Council, the Penwith Gallery was able to employ professional

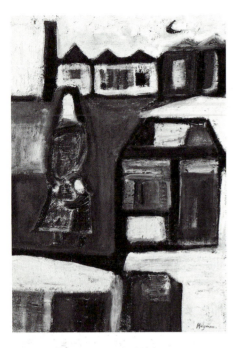

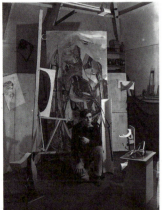

Top:

Patrick Hayman **Mother and Child near a Town** 1952 *Tate Gallery* Bequeathed by Miss E.M. Hodgkins (T02239)

Above:

Peter Lanyon with 'Porthleven' in progress in his attic studio 1951. Photograph: Studio St Ives *Tate Gallery Archive*

staff, such as its Curator in the first half of the 1950s, David Lewis. Hepworth, Leach and their circle, particularly the musician Priaulx Rainier, developed a St Ives Festival of national importance, in which performances and exhibitions by national figures featured alongside local events. While some, like Lanyon, argued that the Festival was dominated by 'imported' events, the festival revealed that local loyalty could transcend deep aesthetic differences. In one instance this even led to Nicholson writing to the press in defence of the St Ives Society of Artists when it was picked on by a visiting critic.

In 1951 the Festival of Britain provided an opportunity for many of the artists associated with St Ives to make ambitious new works. The Arts Council commissioned a range of pieces from contemporary British artists, the chief requirement being that they should be large, at least 45 by 60 inches (114.3 x 152.4 cm). Peter Lanyon made 'Porthleven', Patrick Heron 'Christmas Eve', and Bryan Wynter 'Blue Landscape'. In all these works formal exploration of colour, space and line is combined with narrative or symbolic content.

The more abstract nature of Terry Frost's work from the same period reflected his personal interest in the increasingly pure forms of art sought by Pasmore, Heath, and their circle. They, together with artists like Kenneth and Mary Martin, were pursuing a continuation of the Constructivist aesthetic stated in *Circle* in the 1930s.

Nicholson's own work found a new breadth and clarity in the immediate post-war years. In many of his paintings he created highly refined, near abstract variations on the theme of objects on a table top. However, his mural for the

Festival of Britain was totally abstract, referring back to his more austere work of the later 1930s. Barbara Hepworth too became an increasingly prominent figure in British art, making a major sculpture for the Festival of Britain site on the South Bank in London, and representing Britain at the 1950 Venice Biennale.

For some St Ives artists the example

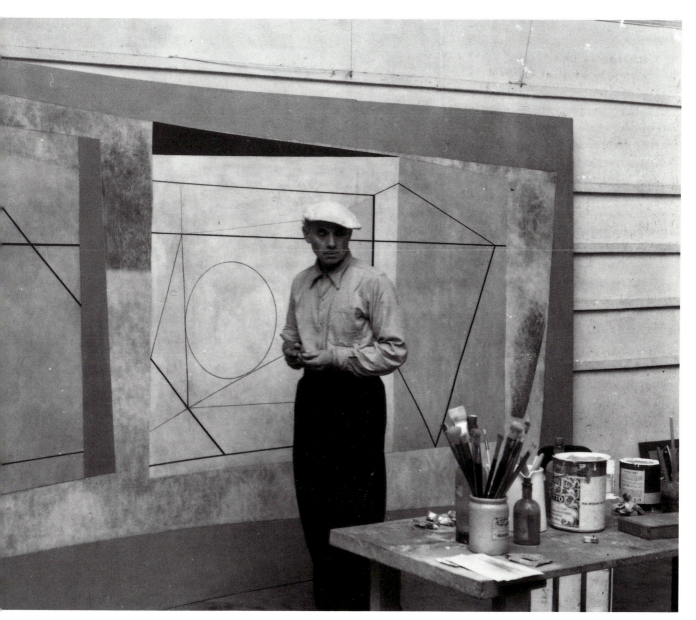

Hepworth and Nicholson was critical, though there were reservations about their influence on the Penwith Society and their dominance of critical perception in St Ives. They exemplified serious, professional artists. Their self-discipline and clarity of purpose in the studio are testified to by many of the younger generation. Equally important was the direct support they provided: Frost,

Wells, Denis Mitchell and John Milne and many others worked for Hepworth as assistants.

Hepworth and Nicholson's professionalism, sense of purpose, and high standards, were fuelled by a single minded commitment. But life was still hard for artists, even those who achieved success in exhibitions, and good reviews.

Ben Nicholson in his Porthmeor studio, January 1951 *Tate Gallery Archive*

Peter Lanyon *1918-1964*
Porthleven 1951

Oil on board

244.5 x 121.9 (96 1/4 x 48)

Presented by the Contemporary Art Society 1953

N06151

This painting is a turning point in Lanyon's work. It was one of the large works commissioned by the Arts Council for the Festival of Britain in 1951. Lanyon expended intense energy on researching how he was to translate his experience of the town of Porthleven into the painting. In constructions and drawings he explored the way the town drops in a narrow, steep valley to its harbour and the sea. He also wished to convey his sense of a structure under the surface of the land which paralleled the human form with its skeletal interior.

Lanyon made numerous versions of this compostion, including a full size one which was destroyed. This one was painted in a few hours on a fresh piece of hardboard.

The result is a painting which has directness and immediacy of execution but a density and complexity which comes from the depth of knowledge the artist gained in its preparation.

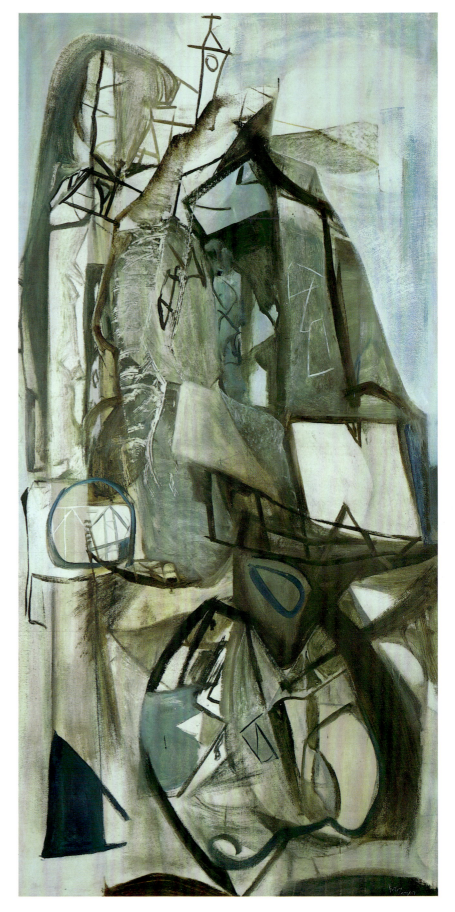

Ben Nicholson OM *1894-1982*
Feb 28-53 (vertical seconds) 1953
Oil on canvas
75.6 x 41 (29 3/4 x 16 1/8)
Purchased 1955
N00051

In the early 1950s, Nicholson produced a
series of paintings in his studio which show
him at the height of his powers. Following
his changes of direction in the 1940s, they
bring together the different strands of his
art. They cannot be read purely as
landscape, still life or abstract; instead
they suggest shifting readings on each
occasion they are seen.

'Feb 28-53 (vertical seconds)' is a good
example of this. Its title combines simple
fact – a date of completion – with evocative
associations. The composition is a series of
lines which build around vertical forms.
Here and there curves suggest the edges of
glasses, vessels, mugs. A line towards the
top might be a table top or horizon. The
patches of colour float in the upper half of
the work, anchoring the composition while
the scrubbed-out spaces in the lower part
create a foreground.

In a note to the Tate's conservators,
Nicholson requested that the pin-holes
made while the painting was in progress
should not be repaired. He emphasised
that for the painter, every detail of the
physical nature of the painting contributed
to its finished presence.

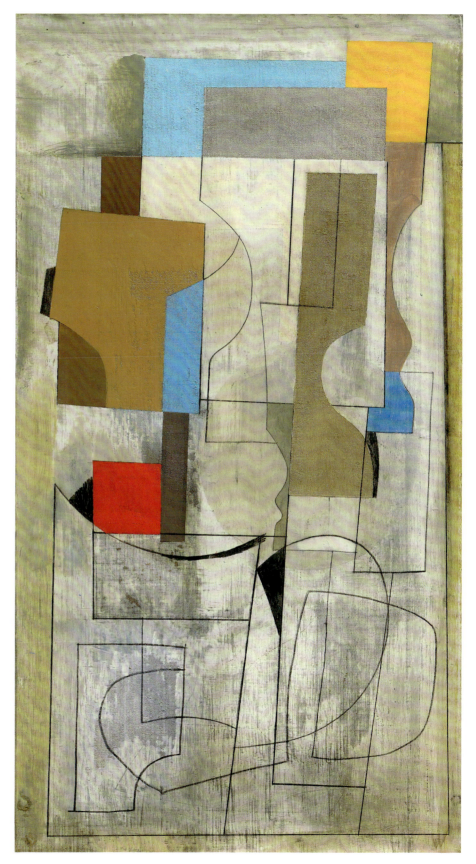

Victor Pasmore *born 1908*

Spiral Motif in Green, Violet, Blue and Gold: The Coast of the Inland Sea 1950

Oil on canvas

81.3 x 100.3 (32 x 39 ¹/₂)

Purchased 1953

N06191

In the 1940s Victor Pasmore established a reputation for subtle, atmospheric paintings of interiors and townscapes. However, by 1950 he was exploring a pure form of abstraction. This was the result of a desire to revive the progressive abstract art pursued by the modernist artists of the 1930s, including Nicholson. Pasmore began to test the expressive potential of line and colour, particularly in a series of works, of which this is one, where colour is carried in spiralling patterns.

This experimental approach was beginning to feature in Pasmore's teaching at Camberwell School of Art, where Terry Frost was one of his students. Frost's and Heron's descriptions of St Ives and the work going on there led to Pasmore visiting the town on a number of occasions in 1950. There he met Nicholson, and other artists working in the locality.

The direct relationship between the visits to St Ives and the evolution of Pasmore's work into abstraction is most clearly demonstrated by the series of drawings he made of Porthmeor Beach. One of these is in the Tate's collection. It shows natural forms – clouds, waves and rocks – each depicted by different types of drawn line. This creates a contrasting sense of space in each passage of the picture.

Despite the apparent similarities between the St Ives drawing and this painting, which was made in the artist's London studio, Pasmore has always sought to emphasise the abstract nature of both. He also links them to other works, such as his paintings based on snowstorms. Of the beach drawings he has written '[They] are quite independent and complete works and in fact done after I had conceived the spiral formations leading to the Snow Storm painting' and of this painting he remarked 'The coast of the Inland Sea is, in this picture, a sea coast of unconscious experience. It does not refer to any coast seen or known by the artist. The word "inland" here denotes this extreme subjectivity'.

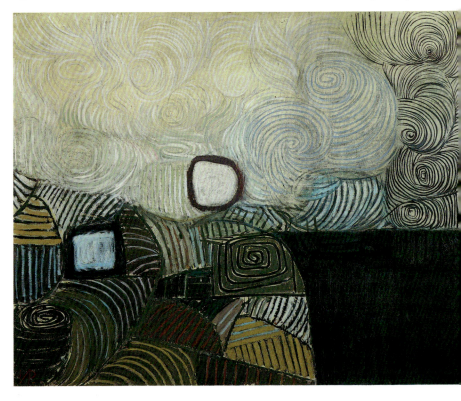

Terry Frost *born 1915*

Black and White Movement 1952

Oil on board

77.8 x 101.6 (70 x 40)

Purchased 1992

06607

After arriving in St Ives in 1946, Frost began a series of works which rapidly evolved into pure abstract explorations of colour and line, but retained associations with the outside world. This development began with a group he titled 'Walk along the Quay', where the lines of ropes and reflections of boats and sails in water are structured in a rhythm which 'walks' up the canvas.

This painting comes from a group which followed on from the 'Walk' series. The curved forms in these paintings are recognisably boat-shaped. But Frost's concern was not so much to evoke boats in harbour or their trappings as the movement associated with them: a series of rocking, swaying and tipping gestures which bounce and surge as if driven by the rise and fall of water. Here the exclusive use of black and white emphasises the forms and rhythms.

The artist's close friend and fellow painter Adrian Heath wrote of this period of Frost's work: 'even the single geometric shapes which he used as structural elements in the early fifties seemed dissatisfied with their role, especially the circles which always seem anxious to play the part of a moon or a sun. However, these interpretations are never forced upon the spectator but they must be read as indications of his desire to relate his art to the world that he knows and enjoys.'

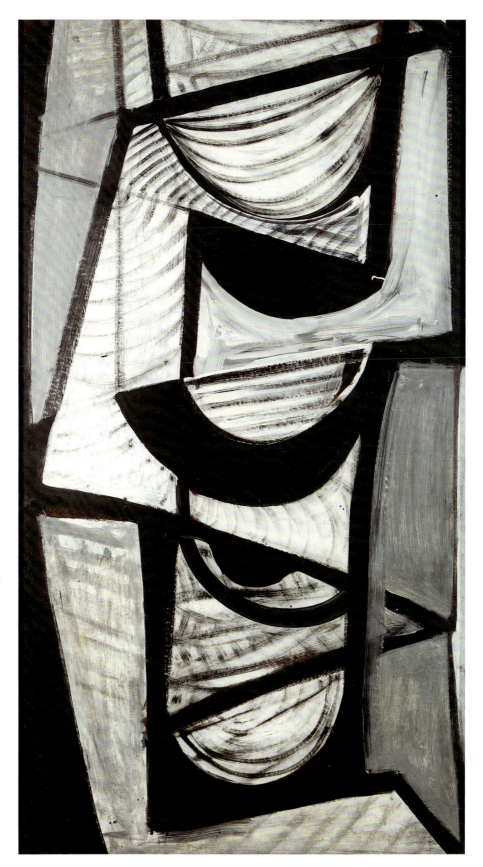

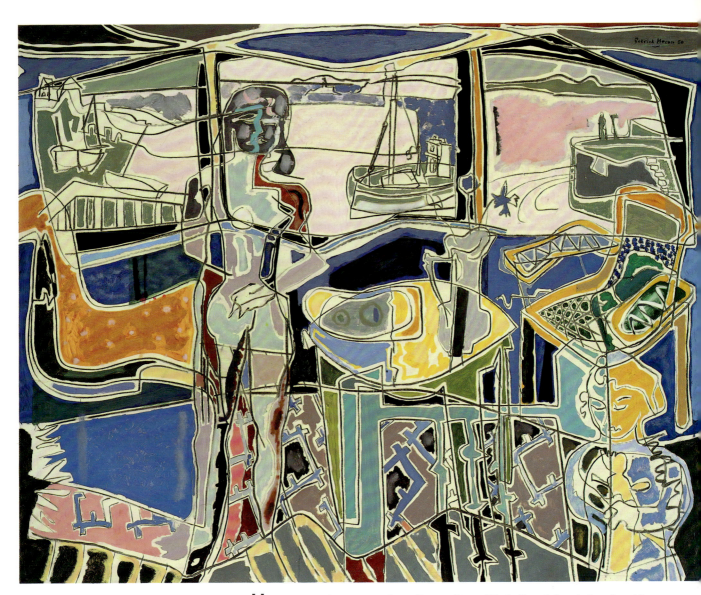

Patrick Heron *born 1920*
Harbour Window with Two Figures;
St Ives: July 1950 1950

Oil on canvas

121.9 x 152.4 (48 x 60)

Purchased 1980

T03106

Until he moved permanently to Cornwall, Heron and his family regularly stayed in St Ives in a house in St Andrew Street, overlooking the harbour. This painting is one of a series based on the main room of the house and the view from its windows. In these works the artist worked out his personal language in response to the French artists he admired: Braque, Bonnard and Matisse.

The motif of the figure and still life in front of a window was the recurrent theme of these paintings. Heron would work on them away from the house itself – in this case first in a St Ives studio lent by Denis

Mitchell, and then in London. His memory fused different views from each window and in this series, Heron has, in fact, created a frieze of images in which the viewpoint shifts, as if we were turning to take in the whole of St Ives Bay.

The different motifs activate different areas of line and colour in the painting. They appear as if pieced together by the artist's memory. Heron has remarked on the vivid sense of place he had at this time: 'while I work away, there in London, I cannot think – with my conscious mind – o anything but my St Ives room, with its window. While I paint I am in St Ives.'

Wilhelmina Barns-Graham *born 1912*
Red Form 1954
Oil on board
34 x 41.8 (13 3/8 x 16 1/2)
Bequeathed by Miss E.M. Hodgkins 1977
T02238

This work is completely abstract, in as much as it is first and foremost an exploration of how a form is perceived in space when it is drawn against an ambiguous floating background. The structure of the form is from the artist's experiments with making drawings based on the golden section. The red of the form is chosen as an 'unnatural' colour in order to prevent potential landscape readings.

In a revealing anecdote about her childhood, the artist once drew attention to the fact that, like most children, she made abstract art before making so-called representational art. The latter only began when she encountered formal art education. Of these childhood drawings she said 'The earliest were rectangles, outlined in chalk of one colour, the rectangles or angular shapes were then filled in with usually a different colour, in chalk or watercolour, or two separate layers of colour imposed on the other.'

From the early 1950s onwards Barns-Graham's abstract paintings have often been made at the same time as figurative or landscape drawings. These deal with problems of placing figures and landscape forms in a relatively traditional picture space. For example, at the same time as making 'Red Form' the artist was drawing a friend with a dog. The artist's first instinct, however, is to make the work in pure forms in its own right.

Roger Hilton *1911-1975*
February 1954 1954

Oil on canvas
127 x 101.6 (50 x 40)
Purchased 1970
T01230

At the time of making this painting Hilton was living in London, in close touch with many of the artists who were associated with Cornwall. The body of work he made at this time is in many ways the most determinedly abstract of his whole career.

In his writings then Hilton often referred to the real nature of painting being its physical presence. 'No representation of the human figure can compete, for me, with a picture which comes out to meet space, which, as it were, participates in something which is real – just as it is real when we move around a room. Space is the vehicle in which we live. It is the great unknown quantity . . . But we do not have to explain why we like these kind of pictures. They are real. They clang like a bell. They do something. They act. They are immediate. The spectator is not called upon to compare the image with real life; he is asked only to see what is there . . . If we are interested in solids, it is the picture which is the solid.'

In his works of this short period, which can sometimes appear to be tranformations of Mondrian's black, white and primary coloured compositions, the paint sits as a thick surface layer. The bare canvas underneath can occasionally be glimpsed, emphasising how the artist has spread the areas of paint over it. The depth of colour achieved adds to the physical impact of the work, and although this painting is somewhat smaller than many contemporary works, it achieves the artist's aim to make works which occupy and animate the whole space in which they are installed.

William Scott *1913-1984*
Winter Still Life 1956

Oil on canvas
1.4 x 152.4 (36 x 60)

Presented by the Contemporary Art Society 1957

T00119

Scott's contact with American art in 1953 helped to establish him as an important figure in the development of post-war painting in Britain. While he never lived permanently in Cornwall, he was closely associated with most of the artists who did, notably Wynter, Lanyon and Frost, and he was particularly close to Heron. They shared his broad interests in the international scene. Through his work as Senior Painting Master at Bath Academy of Art in Corsham Court, Scott and his colleagues led many of the new developments in advanced painting.

However, between 1954 and 1956, he made an important critical reassessment of his own work. Looking back at his own highly abstract painting of the preceding few years, and considering the impact of meeting American artists like Jackson Pollock, Mark Rothko and Franz Kline, he felt that, ironically, it confirmed his own different and distinct identity.

'My personal reaction was to discontinue my pursuit of abstract art and to try and put my earlier form of symbolic realism on a scale larger than the easel picture, with a new freedom gained from my American visit. I felt now that there was a Europeanism that I belonged to, and that many qualities of painting which were possessed by my friends might elude an American i.e. our disregard for technical "know how" and the quality that the French call "gauche"'.

'Winter Still Life' is a remarkably powerful example of what Scott must have had in mind. It has great physical presence, and the wintry blues, greys and browns are intense and charged. Though the painting has all the elements of a traditional still life, it nevertheless feels individual and of its day.

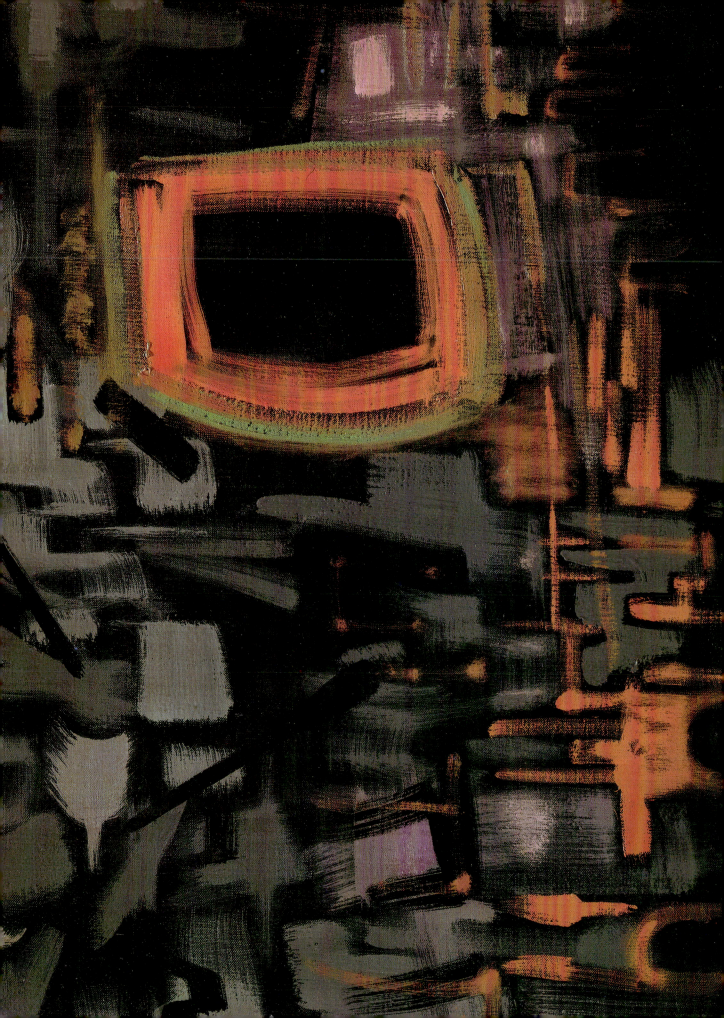

St Ives in an International Context

ront cover of *Britain's Art Colony by the ea* published by George Ronald 1959

eft:

ryan Wynter

Mars Ascending 1956 (detail)

ee page 65

In 1956 a major exhibition, *Modern Art in the United States,* was held in London at the Tate Gallery. A small section of the exhibition was devoted to examples of Abstract Expressionism. For almost a decade previously this work had been discussed by a handful of artists and critics in Britain, and had occasionally been shown in exhibitions here. Never before, however, had it been seen centre stage, and over the next three years a series of exhibitions in London established a widely held view that the new American art was the dominant modern idiom, a view promoted in the critical writing around these exhibitions from the United States. There is no doubt that some of this writing formed part of the America's Cold War rhetoric: Abstract Expressionism was seen as exemplifying Western individualism and confidence, in contrast to Socialist Realist art which employed the traditional academic forms of representation that abstract art rejected.

But this was only one element in a complex critical debate. For example, European abstract artists were often described as following American develop-ments, despite the fact that many of them, including the younger St Ives artists, had helped to create the context for the positive reception, in New York as well as in Britain, of the new American painting. In 1956 Patrick Heron was London correspondent of the American magazine *Arts* where he wrote of the Tate show 'I was instantly elated by the size, energy, originality, economy and inventive daring of many of the paintings. Their creative emptiness represented a radical discovery, I felt, as did their flatness, or rather, their spatial shallow-ness. I was fascinated by their consistent denial of illusionistic depth, which goes against all my instincts as a painter.'

Davie, Frost, Heron, Lanyon and Scott had a series of important solo exhibitions in New York, while Paul Feiler, Alexander Mackenzie, Wells and Mitchell were also featured in American exhibitions. These paralleled successes in Britain and continental Europe. Over this period many of the artists who were active in the St Ives area, such as Feiler, or closely associated with it, such as Scott, had prominent roles in teaching institutions, as well as achieving maturity in their work. They were joined in the town and the Penwith area by many other artists, some of whom chose only to make brief visits, curious about its special atmosphere. Others stayed on to work in the unique conditions, savour-ing the distinctive landscape, and the community's extraordinary range of personalities. Many younger artists who were interested in the new abstract art worked in St Ives at this period. They included Sandra Blow, Trevor Bell, and Bob Law among many others. Teaching institutions played a part in this burgeon-ing of contact between artists in Cornwall and elsewhere. Of particular note were the West of England College of Art, where Feiler led the teaching, and perhaps even more important, Bath Academy of Art, then at Corsham, near

Bath, where William Scott headed a remarkable body of teaching staff.

St Ives art gained a reputation as a European form of abstraction which remained rooted in the observation of nature. In this respect is was distinctively different from the new American art. The success of the St Ives artists came at a time when the pace of change in art was increasing, and when an expanding art market was hungry for new material to promote. In these circumstances it appeared to some observers that the St Ives artists had paved the way for newer work, more directly responsive to the values of American art. Frost, Heron, Wynter, Lanyon and their peers began to be referred to as the 'middle generation'. When a group of younger artists organised the landmark exhibition of new British abstract art, *Situation,* at the RBA Galleries in London in 1960, differences became explicit: the catalogue made a point of stating that the works in the exhibition 'should be abstract (that is

without reference to events outside the painting – landscapes, boats, figures – hence the absence of St Ives painters, for instance), and not less than thirty square feet'.

Through the 1950s the leading St Ives artists evolved distinctive personal styles, and they were also involved in and aware of working situations outside St Ives. From 1954-6 Terry Frost, for example, was Gregory Fellow at Leeds University. This involved term-time residence at the university and gave his work fresh impetus and a new weight. Later he made his home in the Midlands in order to keep in touch with his increasing commitments to teaching. In 1956 Bryan Wynter's work developed dramatically when, during a ten-month break in London, his experiments with the perception of space and movement led to a distinct and original sequence of new paintings, in which he used solid marks of colour to weave shifting veils of light. In 1957 Peter Lanyon had his first one-man show

in New York, and met American artists such as Mark Rothko. Working in Cornwall between bursts of travel, his interest in looser, more ethereal painting combined with his new enthusiasm for exploring the Cornish coastline through gliding. In his paintings from the late 1950s and early 1960s he deploys what appears to be a purely abstract language of brushmarks, colour and space but still maintains a reference to place. This reference is not literal or direct but is an expression of Lanyon's experience of the landscape filtered through memory.

In 1956 Lanyon had renewed earlier criticisms he had made of what he saw as the narrowness of the Penwith Society and of the influence on it of the dedication to abstract art of Nicholson and Hepworth. In a letter to the *St Ives Times,* he pointed to a touring exhibition of six young figurative artists visiting the Falmouth Art Gallery as an example of what was not shown in the Society's gallery, and suggested that art in St Ives would benefit from a greater pluralism.

Such a pluralism was, however, emerging. On one hand some artists were clearly making abstract work: Heron moved permanently to Cornwall in 1956, the same year as Lanyon's protest. He began to produce original and powerful large-scale painting, and by early 1957 had created his first truly abstract work. On the other hand, from 1956 Roger Hilton spent more and more time in Cornwall, this period coinciding with his first survey exhibition, held at the Institute of Contemporary Arts, London in 1957. In contrast to Heron, however, Hilton at this time reintroduced figurative elements into his work. Other artists – Barns-Graham for example – revitalised the abstract forms in their painting by continuing drawing

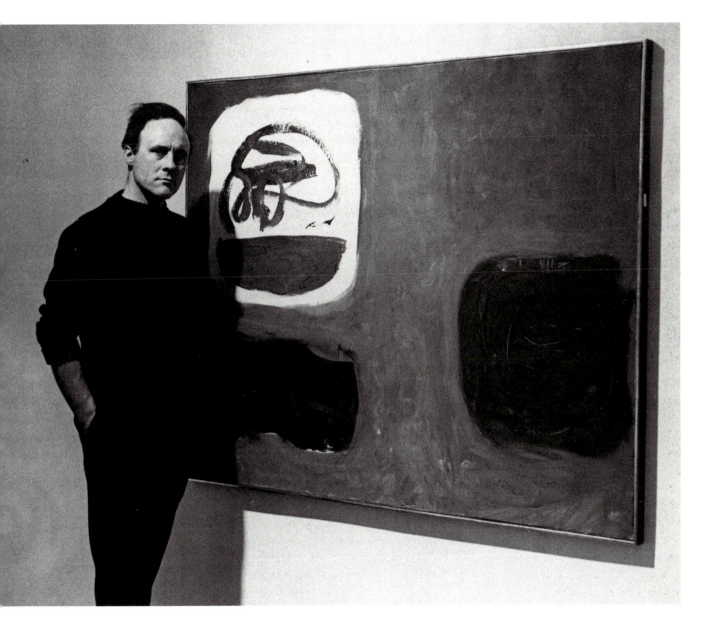

n the landscape, or occasionally even
he figure. Of course, artists such as
arl Weschke, Alan Lowndes and
atrick Hayman, resident in St Ives and
enwith, are examples of those who
ractised modern figurative work, and
o have never been closely associated
ith the other 'St Ives' artists.

Above:
Patrick Heron at the Bertha Schaefer
Gallery New York 1962

Opposite page:
Tea at Chapel Kerris 1958. Left to right
Meli Rothko, Mark Rothko, Terry Frost
(hidden), Marie Miles, June Feiler, Helen
Feiler, Christine Feiler, Anthony Feiler
and Peter Lanyon. Photograph: Paul
Feiler

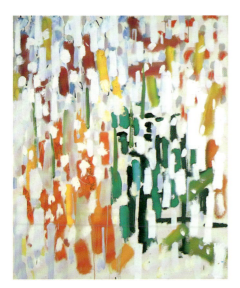

Patrick Heron *born 1920*
Azalea Garden: May 1956 1956

Oil on canvas

152.4 x 127.6 (60 x 50 1/4)

Purchased 1980

T03107

In 1956 Heron decided to settle in Cornwall, in a house he had lived in during childhood, on the moors above the sea between St Ives and Zennor. This move prompted a new clarity and simplicity in his work, which evolved rapidly over the first year or so of his living all year round in Cornwall. 'Azalea Garden' is one of a series of paintings based on his experience of his new garden.

The garden paintings of 1956 were more abstract than his previous work, although 'Azalea Garden' is to some extent an impressionistic evocation of his surroundings. In it soft hues hang in a shallow space, intense short brushmarks are built on an underlying structure. These paintings rapidly led to a flatter structure in which vertical marks were bonded with short horizontal marks. In some, these marks form a veil across the whole painting. Most of these paintings were done on a thin, white ground.

Early in 1957, Heron revised this dense mark-making. As if to cleanse his painting of the intense layers of short dabs of colour, he created a new body of work, starting from one small canvas, called 'Vertical Light' (Private Collection), in which the painting was dramatically reduced to just a few sweeps of colour across the white space of the canvas.

'Horizontal Stripe Painting' is one of the works which ensued. It marks the end of the process begun in the group that includes 'Azalea Garden'. The colours have become hot and dense. The painting has sometimes been taken to have a relationship to landscape – sky above sea, perhaps – but like much abstract painting often suggests musical analagies. The artist himself has written of 'spatial bars which ascend in chords of different reds, lemon-yellow, violet and white up the length of my vertical canvas.'

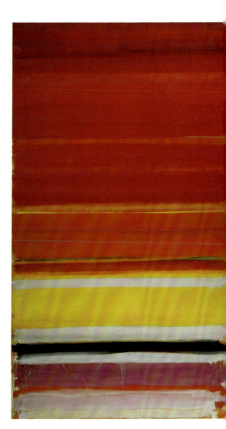

Patrick Heron *born 1920*
Horizontal Stripe Painting: November 1957-January 1958 1957-8

Oil on canvas

274.3 x 154.8 (108 x 61)

Purchased 1972

T01541

Bryan Wynter *1915-1975*

Mars Ascending 1956

Oil on canvas

152.7 x 101.3 (60 ¹/₈ x 39 ⁷/₈)

Presented by Fello Atkinson 1981

T03289

In 1956 Bryan Wynter gave up teaching at Bath Academy of Art in Corsham Court, left behind his studio at Zennor, and spent ten months in a borrowed studio in London. A windfall bequest from a relative allowed him to concentrate solely on his painting for the first time in his life. He took the opportunity to rethink the direction of his painting, in particular the part played by the descriptive and symbolic elements which characterised his earlier work.

His first completed paintings from this time show greater emphasis on surface marks, colour, and spatial illusion. This development arose partly from his deep thinking about his immediate visual surroundings, particularly objects within the interiors of his studio and living room, and partly from his experiments with different ways of perceiving objects in space.

'Mars Ascending' was painted after the artist had settled back into his small cottage on the moors above Zennor. Its surface is charged with veils of red marks, which overlay other layers of different hues, until in the depths of the painting browns and blacks suggest its distant beginnings. Wynter wrote in 1957 of how he was trying to give the eye the chance to see in a pure way. 'I find it helpful to think of that moment at which the eye looks out at the world it has not yet recognised, in which true seeing has not yet been translated into the useful concepts with which the mind immediately swamps it. This moment of seeing is in fact a fragment of a continuing process which underlies and precedes recognition.'

Wynter's earlier work had possessed a romantic symbolic quality. The new, more abstract works were also given titles which suggested symbolic and personal associations. These associations, however,

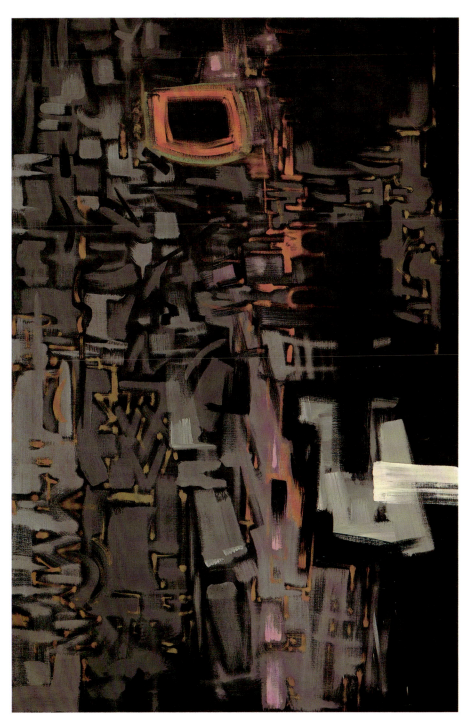

were loose, not specific, and intended to help identify the particular work and suggest ideas. He wrote 'One should be able, ideally, to make paintings which throw off imagery of different kinds at different times to different people, continually unfolding different aspects of themselves, ambiguous and paradoxical paintings with no main "theme" from which the spectator may, by participation, extract his own images.'

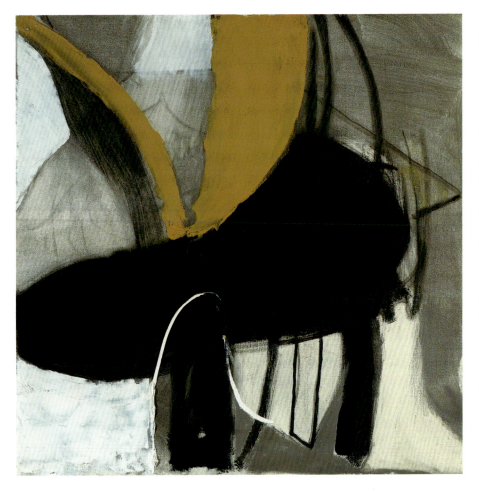

Roger Hilton *1911-1975*
January 1957 1957

Oil on canvas
66 x 66 (26 x 26)
Purchased 1958
T00173

This is one of the first works Hilton painted in St Ives following his decision to move to Cornwall late in 1956. Like 'February 54', the painting is titled simply by the date of its completion, emphasising the artist's wish for the painting to be seen in itself, not in any representational way.

However, it also shows how his move to live in Cornwall came at the point at which the most severely abstract moment in Hilton's work was passing. The surface of the paint is now broken up, forms separating, and freely drawn lines suggesting that, by comparison with the thickness and tightness of the earlier painting, the artist was relaxing his grip.

One effect of this loosening is that the shapes and colours prompt other visual associations. For example, while the work of the previous four to five years had been dominated by permutations of primaries and black and white, 'January 57' is in earthy browns, greys and greens. Moreover because the forms are more organic, they permit associations with natural forms, and shapes seen in the landscape.

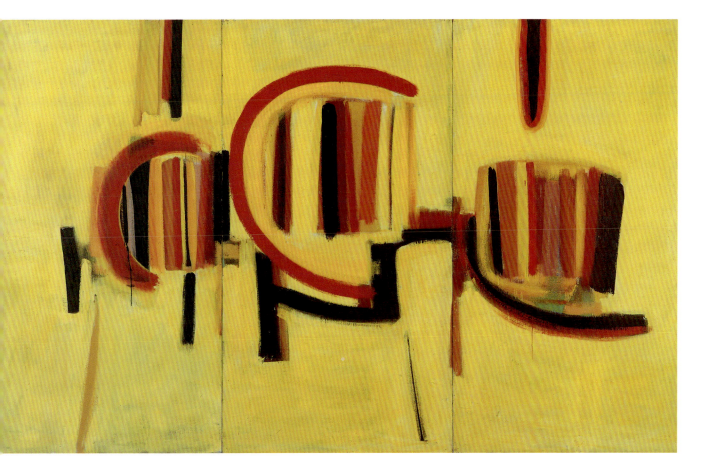

erry Frost *born 1915*
ellow Triptych *1957-9*
il on board
28.6 x 365.7 (90 x 144)
rchased 1992
06608

This work was made in Leeds in 1957. Frost had completed his Gregory Fellowship at Leeds University, but had stayed on to join in its innovative teaching programme. The painting's clear structure, and simple but dramatic colour range, in part reflect the emphasis on exploring the effects of colour and space being developed by Harry Thubron in the Leeds course. Frost also feels that the grand scale – unusual in his work up to that date – was directly prompted by his awareness of the Yorkshire landscape compared with that of the Penwith peninsula.

In Cornwall, he has remarked, 'you can stand like a giant above the landscape', while in the Yorkshire Dales, places like Gordale Scar loomed over him, making him feel tiny. The painting was made in a room so small that he could not step back to see it whole, but it creates the sensation of a huge space in which the forms float above the viewer.

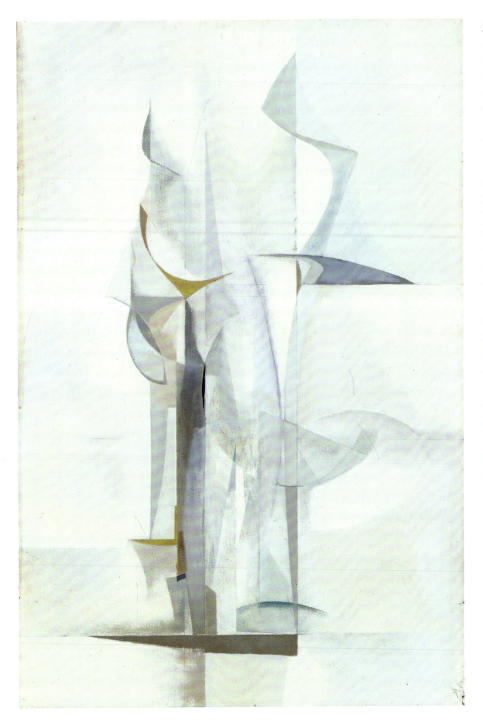

John Wells *born 1907*
Aspiring Forms 1950
Oil on board
106.7 x 72.4 (42 x 28 ¹/₂)
Bequeathed by Miss E.M. Hodgkins 1977
T02231

This work – one of Wells's largest – sums up some of his central interests. Light, curved forms, sometimes recalling birds in flight, turn on a subtle, half-hidden grid. This structure allows repeats and shifts in the same way that the fugue in musical form develops related themes. The painting is in colours which have natural associations with sea and sky, but is clearly abstract.

Wells is the author of one of the best-known passages discussing the pleasures and problems of making abstract art. In a letter to the firmly romantic and figurative sculptor, Sven Berlin, he wrote in 1948: 'the morning air and the sea's blue light, with points of diamond, and the gorse incandescent beyond the trees; countless rocks ragged or round and of every colour birds resting or flying, and the sense of a multitude of creatures living out their minute lives . . . All this is part of one's life and I want desperately to express it; not just what I see, but what I feel about it.'

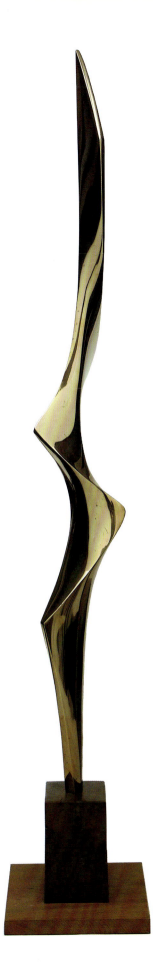

Denis Mitchell *1912-1993*
Turning Form 1959

Bronze

142.2 x 17.8 x 27.9 (56 x 7 x 11)

Bequeathed by Miss E.M. Hodgkins 1977

T02235

Both John Wells's 'Aspiring Forms' and this
work were originally bought in St Ives by
Miss E.M. Hodgkins. Although the Wells
predates the Mitchell by about nine years a
comparison bears out Denis Mitchell's
remark that the painting was probably in
his mind when he was working on the
sculpture. Miss Hodgkins was to include
both in her important bequest of St Ives
art to the Tate.

'Turning Form' reflects not only Mitchell's
close relationship with Wells, but the
important part he played in Barbara
Hepworth's studio. He worked there as
her assistant from 1949 to 1959. The
smooth, flowing surfaces of the sculpture
and the way line travels through it in a clear
upward movement shows his subtle
transformation of both these influences
into a consummate whole.

It is a testament to Mitchell's own
technical accomplishment and the resources
available to artists in Cornwall that such a
refined work was fabricated entirely in
Penwith. The original plaster was made in
Mitchell's studio in St Ives (he was later to
share a building in Newlyn with Wells), and
cast in a foundry in St Just. Many visitors
testify to how Mitchell's studio itself became
a place to come to and learn, his skills and
awareness passing on to many younger
artists. This together with his long period
as Chairman of the Penwith Society, and his
broad interests in the work of other artists,
made his studio a centre of activity.

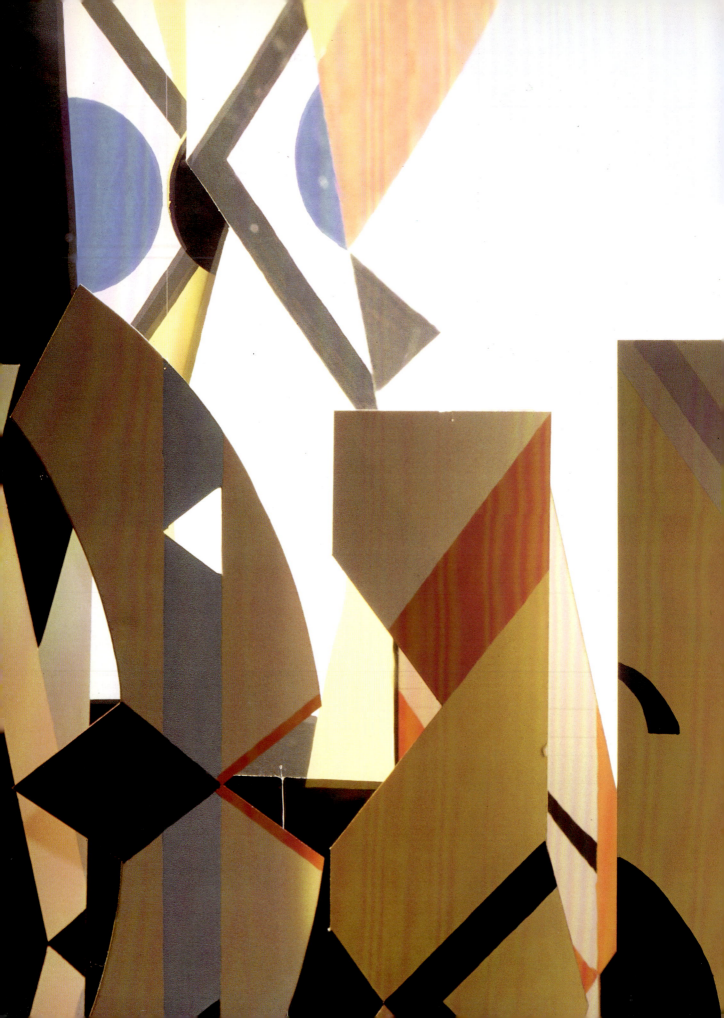

A Distinct Approach

Above and left (detail):
Bryan Wynter *1915-1975*
Imoos VI 1965
Mobile: Gouache on card with a
searchlight mirror and electric lamps
109.2 × 101 × 116.8 (43 × 39 3/4 × 46)
Purchased 1965
T00765

Many believe that with Lanyon's tragic death in 1964, as a result of a gliding accident, the great era of St Ives art ended. However, it is possible to see in Lanyon's very last works the emergence of new directions which were afterwards pursued by the 'middle generation' painters. An example is Lanyon's use of fragments of real objects, hard surfaces that he floated onto or forced into the free marks of his painting, an idea which he had previously explored only in private in his working constructions. Echoes of this practice are found in the way Bryan Wynter used found elements and cut-out coloured card to extend the floating coloured marks in the three-dimensional kinetic works which he called 'IMOOS': 'Images Moving Out Onto Space'. Terry Frost experimented with hanging objects, collaged elements, and painted sculpture from the late 1950s onwards.

Works of this kind, constructions, manipulated found objects, and kinetics, relate the St Ives artists to a widespread exploration of unconventional media in the mid-1960s. A key difference, however, was that the St Ives work continued to refer back to painting. Wynter, for example, continued to produce paintings which are closely related to earlier kinetic works. He thus came full circle: kinetic works which began as a way of extending a painter's perception of nature, came to assist the artist in distilling that nature back into two-dimensional form.

The beauty of St Ives played a part in

Above:

Alexander Mackenzie **Drawing,
June 1963** 1963 *Tate Gallery*
Bequeathed by Miss E.M. Hodgkins
1977 (T02240)

Below:

Canoeing in Co. Kerry 1964.
Photograph: Bryan Wynter

publicising the art with which it was associated. Publications such as those by the writer Denys Val Baker helped to broaden the discussion of the arts practiced in West Cornwall by embracing all the art forms and blurring the distinctions between practices characterised by others as modern or traditional. Val Baker speculated on the relationship between new art in Cornwall and deep rooted perceptions of the unique Cornish heritage and landscape.

The idea that 'St Ives' denoted a certain style, however, can cloud our understanding of the diversity of the work made by artists associated with the colony from the early 1960s onwards. The frame of the town and its surrounding region meant that huge numbers of artists – for too many to list here – came and worked here. Artists who later made quite different work, such as sculptors Elena Gaputye or Marie Yates, spent periods of their careers here. Others were to come and go, seeing St Ives as a spiritual home despite working elsewhere. Over the next two decades, literally hundreds of artists

were to spend key periods of their lives in West Cornwall.

American artists and critics were among those drawn to St Ives in the late 1950s and early 1960s. Mark Rothko came to see Lanyon, with whom he had made contact in New York, and Heron, whom he knew as a writer as well as a painter. He naturally met many of the other artists working in the area. Heron and Scott's wide contacts ensured a steady stream of further visitors, including the critic Clement Greenberg. However, many of the British artists came to feel that these contacts confirmed the distinct nature of their work compared with their American counterparts. As the 1960s wore on, it was felt by some that the dominant critical context created by the Americans was inappropriate for a good understanding of their work.

By the mid-1960s the orthodoxies of modern painting were being reassessed. On one hand, some younger artists and critics saw the flat expanses of American painting as an end to all further possible development in that medium. They increasingly turned away from existing forms of painting and sculpture, developing what by the end of the decade had become known as Conceptual Art. For those who stuck to painting, the dominance of American formalism seemed to narrow the possibilities of what painting could be. As early as 1966 Heron was attacking the 'gutless obsequiousness' of British critics who failed to understand the value and potential of British and European art.

Trevor Bell **Overcast** 1961 *Tate Gallery*

Purchased 1962 (T00765)

Peter Lanyon *1918-1964*
Lost Mine 1959

Oil on canvas

183.2 x 152.7 (72 ¹/₈ x 60 ¹/₈)

Purchased with funds provided by the Helena and Kenneth
Levy Bequest 1991

T06467

Much of Peter Lanyon's painting after his
first exhibition in New York in 1957
reflects his new found stature on the
international art scene, and his confident
relationship to Abstract Expressionist
painting. 'Lost Mine' was painted while the
artist was also working on a large mural for
a new building for the Civil Engineering
Department at Liverpool University. His
paintings from this period show the lessons
learnt from the attempt in the mural to
structure colour and control imagery on a
large scale. Often, as for 'Lost Mine',
Lanyon made constructions as studies in
which he could resolve some of the
questions of structure that arose in his
paintings. The construction for 'Lost Mine'
is made in glass on which Lanyon painted,
so that coloured marks floated on the clear
planes in space.

The subject of the mural reflected the
science of loose bonding hydraulics. This
prompted Lanyon to renew his study of
water, and of the sea and its action on sand
and on man-made structures.

However a painting like 'Lost Mine' also
affirms Lanyon's continuing desire to root
his painting in his native West Cornwall,
and in experiences that relate to his social
and political concerns. So, unlike many of
his American counterparts in the late
1950s and early 1960s, such as Mark
Rothko, he retained overt references to
incidents, places and histories from the
world around him.

The 'Lost Mine' of the title is probably
the Levant Mine, which was the scene of a
fatal accident and was later inundated by
the sea. Lanyon's painting suggests a
physical sense of anger in the brushmarks
and in the red burning at the centre of the
painting beneath the blues, greens and
whites which flow and break above it.

Paul Feiler *born 1918*

Inclined Oval Brown 1964-5

Oil on canvas

91.4 x 101.6 (36 x 40)

Purchased 1965

T00741

Paul Feiler first visited Cornwall in 1949 and settled permanently there in 1953. Like other St Ives artists he sought more or less abstract means to express his response to landscape. His chief concern was with the way in which we experience the major elements of landscape: great mountains for example, or in Cornwall, 'the sea and the rocks seen from a height'. In his painting of the late 1950s and early 1960s these things became abstract 'forms in space where the scale of shapes to each other and their formal relationship convey their physical nearness to the spectator and where the overall colour and texture supplies the emotional overtones of the personality of the "Place"'.

This work is one of the last of a richly textured group from the early 1960s. Some earlier works in the group have titles referring to Cornish place names, but Feiler was increasingly purifying his work at this time and the title here draws attention to his desire to represent his response to landscape in purely abstract terms. This is also indicated by his adoption of a square format rather than the traditional horizontal canvas which in itself suggests the idea of landscape. But despite its austere structure, the painting's handling and colour are redolent of natural forms, suggesting, perhaps, the split boulders in the West Penwith landscape.

Terry Frost *born 1915*
Through Blacks 1969

Acrylic on canvas

198.1 x 259.1 (78 x 102)

Purchased 1976

T02022

'Through Blacks' might at first appear to be a denial of Frost's central interest in colour. However, on looking closely at the painting, it can be seen that it is in fact about the nature of colour. As Frost said 'the picture grew out of the idea that there was no such thing as black, red or white, which Black?, which Red? etc'.

In a teaching exercise Frost challenged a group of students to each paint an area of solid black. He then collected up the individual efforts, spreading them out to show that there were in fact as many blacks as there were people involved in the exercise. This prompted his own experiments with the nature of black as a colour. In this work, he made the blacks by mixing red, yellow and blue in different proportions. He did this systematically on three large canvases on each of which one of the primary colours would be mixed in series of different proportions against a fixed amount of the others. These were then cut up to provide the shapes used here.

As viewers we are therefore presented with a beautiful enigma. The painting as a whole breathes a deep, powerful dark presence. Yet with time, each reflection, each individual component starts to show its own distinct colour.

Frost has said that the painting seemed to him to 'work like a piece of poetry. A sort of wink at the Sun, the kind of moment experienced when lying in the . . . Sun and passing through dream and reverie.

Bryan Wynter *1915-1975*
Saja 1969

Oil and acrylic on canvas

213 x 168.5 (83 7/8 x 66 1/4)

Purchased 1982

T03362

From around 1960 Bryan Wynter became
particularly interested in the possibilities of
kinetic art. Kinetics enabled him to extend
his examinations of the relationship
between his paintings and the visual appear-
ance of the world around him. He made
works in which he hung shapes of coloured
card, to turn in front of large, concave
mirrors. The reflection of the cards in the
mirror created the illusion of colour moving
and changing shape on different planes
within the box-like space of the work.
These effects also acted as a visual metaphor
for how we see colour in natural forms,
such as in flowing water.

Wynter was an enthusiastic canoeist,
and saw canoeing as a way of exploring
landscape. He became fascinated by water,
finding that it prompted thoughts about
painting. He even saw the action of water
as a metaphor for the making of art: 'A
stream finds its way over rocks. The force
of the stream and the quality of the rocks
determine the stream's bed. This in turn
modifies the course of the stream,
channelling out new sluices and hollows.
The stream erodes the rock, the rock
reflects the stream, until, at some high
point, the stream bursts its banks and falls
into a ravine. The dry stream bed, carved
and hollowed, remains. Its form contains its
history. There are no rocks and streams in
my paintings but a comparable process of
dynamic versus static elements has
attended their development and brought
about their final form.'

'Saja' takes its name from a river in
north-west Spain which was explored by
Wynter with his brother on a family holiday
in April 1969. It was painted in a studio in
Newlyn which the artist was using at the
time. The painting achieves a remarkable
harmonisation of formal drawing, complex
layers of space and delicate surface colour.

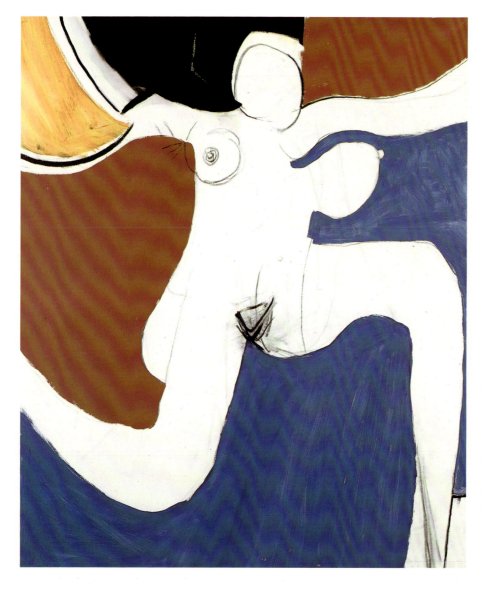

Roger Hilton *1911-1974*
Oi Yoi Yoi 1963
Oil on canvas
152.4 x 129 (60 x 50 3/4)
Purchased 1974
T01855

This is one of Roger Hilton's best-known works. It was made in December 1963. Unusually for Hilton, it can be directly related to a second painting of the same subject, 'Dancing Woman', now in the collection of the Scottish National Gallery of Modern Art. Noting that the sources for his work were always personal, Hilton said of these two paintings that they depicted 'my wife dancing on a verandah. We were having a quarrel. She was nude and angry at the time and she was dancing up and down shouting 'Oi yoi yoi'.'

The remarkable energy and vibrancy of the drawing of the figure, the brilliance of the colours, and the subject of the dancing nude figure have often prompted associations between this painting and the figure paintings of Cézanne and Matisse. Hilton himself denied these as conscious models, but accepted that their example may have been subconsciously at work.

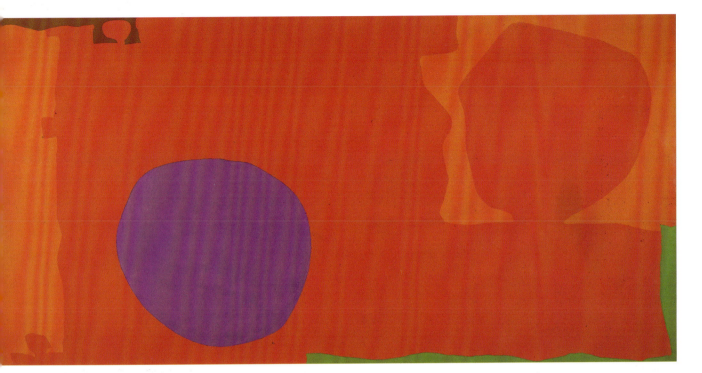

Patrick Heron *born 1920*
Cadmium with Violet, Scarlet, Emerald, Lemon and Venetian: 1969 1969

Oil on canvas
198.5 x 379 (78 1/8 x 149 1/4)
Presented by Lord McAlpine of West Green 1983
T03660

The work's title is simply a list of the colours employed in the painting. In his introduction to the 1953 exhibition *Space in Colour*, Heron stated: 'Colour is the utterly indispensible means for realising the various species of pictorial space.' This remained the artist's central concern. In 1969 he wrote: 'Space in colour. To me, this is still the most profound experience which painting has to offer.' In this painting he is exploring this experience on a large scale. He is also exploring the way in which colours are affected by their neighbours: the eye sees different versions of the same

colour, depending on where in the painting it appears. In the essay quoted above he also wrote: 'I have always been intrigued by observing the way in which first the colour on one side and then the colour on the other side of a common but irregularly drawn frontier dividing them seems to come in front. As your eye moves along such a frontier the spatial positions of the colour-areas alternate – according however to the nature of the loops in that frontier, rather than to any change in the colours – since these do not change.'

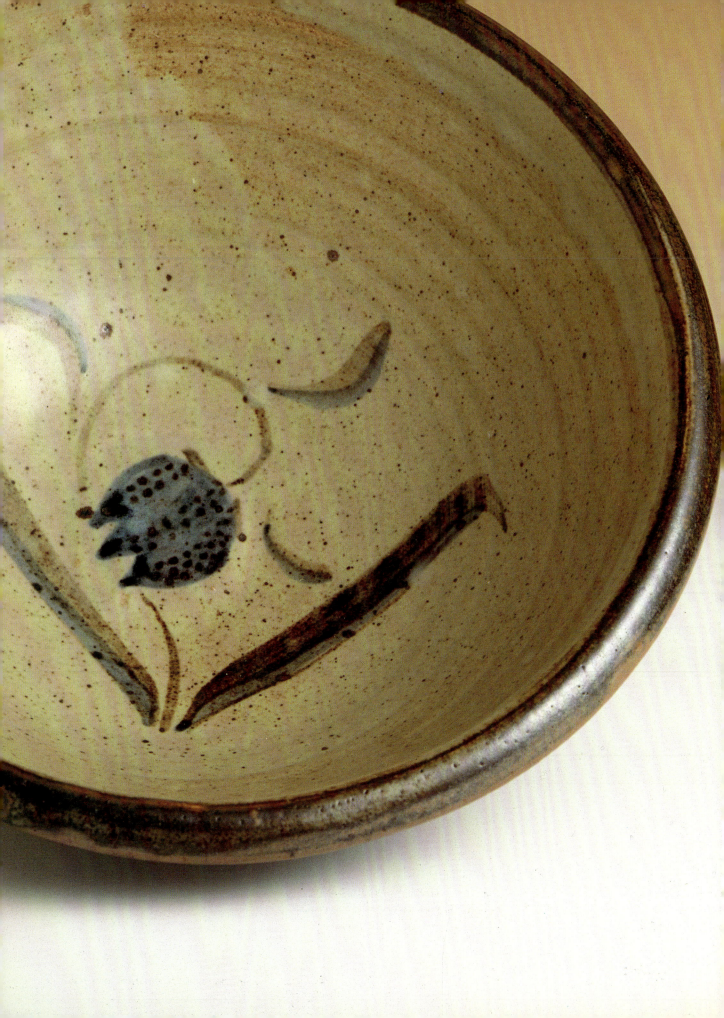

Nicholson, Hepworth and Leach after 1956

rbara Hepworth **Dual Form** 1965 in
e forecourt of the Guildhall, St Ives
68

ft (detail):
rnard Leach
ritillary' bowl, c.1950
oneware
(11 ½) diameter
ingfield Digby Collection

Ben Nicholson left Cornwall for good in 1958. Barbara Hepworth, however, remained firmly in St Ives for the rest of her life, and Bernard Leach always returned to his home in the town between his frequent trips abroad. Although Nicholson spent much of his time working and travelling in Europe, he continued to be viewed, both in the country and abroad, as one of Britain's senior artists. In the 1960s his work continued to revolve around the abstract forms which had re-emerged in it in the early 1950s, but drawing and printmaking became an increasingly important part of his work.

Throughout this period Nicholson became increasingly jealous of his privacy, and did not become a celebrity in the way that many younger artists did in the 1960s and 1970s. In an undated letter in the 1970s, he wrote to the then Director of the Tate Gallery Norman Reid 'I think the point about "television" and "interviews" and "general" but not "serious" publicity (like books and catalogues) is (& I am sure you will agree ...) that the conditions for production of my work must have priority. I also don't like personal publicity which leads to being known or recognised by the general public or even art students as this interferes with my private life & it is this which produces the work.'

Barbara Hepworth's situation was very different at this time. Her career became increasingly public, through commissions such as the memorial to Dag Hammarskjöld, the Secretary

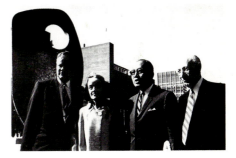

Barbara Hepworth at the unveiling of
Single Form at the United Nations,
New York 1964 *Tate Gallery Archive*

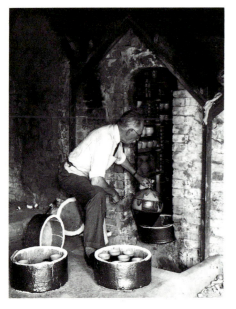

Bernard Leach in his kiln, July 1957 *Tate Gallery Archive*

General of the United Nations killed in 1961, for the new United Nations Headquarters in New York. Even when demand for her sculpture led her to work on an increasingly large scale, and in bronze which required complex casting processes, she continued to live in St Ives, adapting her working space and pursuing her personal life quietly and with a clear focus. In contrast to Nicholson, whose itinerant life is attested to by the subject matter of his later work, Hepworth developed ever more deeply the sense of place St Ives and its surroundings gave her.

Hepworth had a particularly important relationship with the town. She employed local people both in her workshop and through contracts for specialist services such as transport and photography. Some remarkable photographs record how on occasion her work literally spilled out onto the streets of St Ives, as it made its way to casting or siting. Her relationship to St Ives was given official recognition in 1968 when she was awarded, together with Bernard Leach, the Freedom of the Borough. By the time Dame Barbara died in a fire at her studio in 1975, she was one of Britain's best-known artists.

Bernard Leach's sons David and Michael sustained the Leach Pottery's output for many years until they left St Ives to set up their own potteries in 1955. The following year, Leach's future third wife Janet Danell joined him in St Ives and took over the management of the pottery. They were married shortly afterwards. Through the 1960s Leach's importance as a maker of ceramics was confirmed. Major exhibitions of his work were held around the world, publications disseminated his thought and approach, and students came from far afield to study at the Leach Pottery. Leach died in 1979.

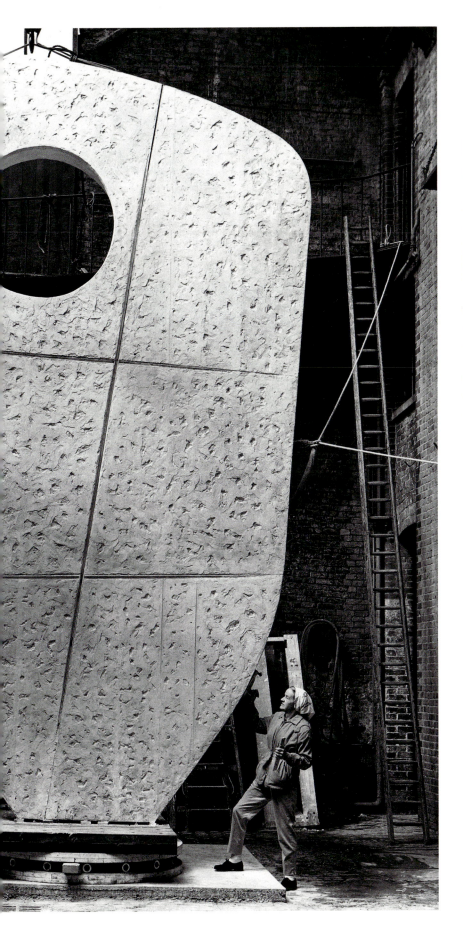

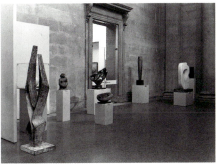

The *Barbara Hepworth* retrospective exhibition, Tate Gallery 1968 *Tate Gallery Archive*

Left:
Barbara Hepworth **Single Form** 1962-3. Photograph: Morgan-Wells

Dame Barbara Hepworth *1903-1975*
Single Form (September) 1961

Wood

82.5 x 50.8 x 5.7 (32 1/2 x 2 1/4)

Presented by the executors of the artist's estate 1980

T03143

From the 1930s onwards Barbara Hepworth made sculptures which consisted of a single upright form. They often prompted comparison with standing stones. They also have an aura of elegy or memorial about them. A.M. Hammacher commented on how an earlier admirer of these works, J.D. Bernal, 'might have quoted the Old Testament in which Jews like Jacob raise a neolithic stone as a memorial on the spot where, sleeping, they had received their heavenly visions'.

In Hepworth's work the upright form occurs in many variations, often suggesting a relationship with the human figure. In many sculptures of the 1950s and 1960s she employs groups of these forms, often subtly modulated into a wider shape with sloping or curved edges, giving the form a new poise and grace.

'Single Form' 1961 has echoes both of earlier upright single form sculptures, and of the new broader, gentle forms of the later multi-part sculptures. Its simplicity and grace is underpinned by a particularly satisfying relationship between the form of the piece and the wood from which it was made.

This work may have been in the artist's mind when she and the United Nations Secretary-General, Dag Hammarskjöld , who had become a friend, first discussed the possibilities for a sculpture for the piazza in front of the new United Nations Headquarters in New York. The artist later wrote ' When I heard of his death, and in order to assuage my grief, I immediately made a large new version of Single Form just for myself. It was 10ft 6ins high.' This in turn was scaled up for the bronze which was unveiled in New York in 1964.

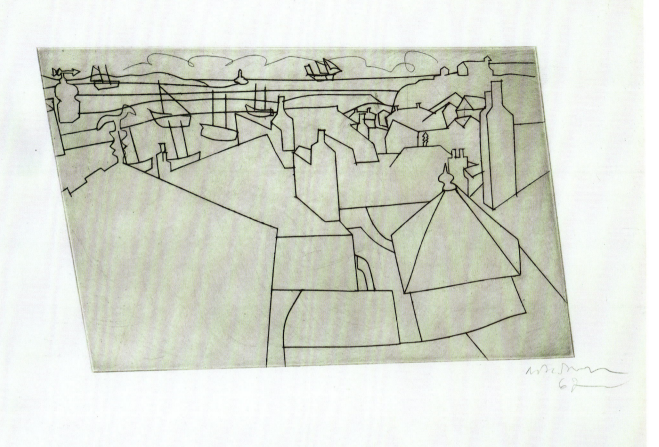

14/50

Ben Nicholson OM *1894-1982*

St Ives from Trezion 1967

Etching on paper

7.5 x 27.9 (6 7/8 x 11)

Presented by Waddington Galleries through the Institute of Contemporary Prints 1975

P01239

This print comes from a series which Nicholson made in Switzerland with the master etcher François Lafranca, between 1965 and 1968. The series was based on drawings from the preceding two decades still in Nicholson's possession.

Nicholson did not return to St Ives in the 1960s, as this series might suggest. But the town and harbour clearly remained fresh in his mind. Here he revisits St Ives through memory and with the help of drawings made there in previous decades.

In the 1960s Nicholson continued to make abstract reliefs, paintings and drawings. But he shifted between these and more figurative work based on still life and landscape. 'St Ives from Trezion' is an imaginative transformation of the view from his former house in the town. It is an example of how Nicholson could create complex compositions with a few simple lines. The sloping edges of the etching plate are used to emphasise the rhythm which swings through the whole scene.

Since 1975 – Living Histories, New Directions

St Ives art was celebrated by two important exhibitions in the 1980s, one at the Tate Gallery in 1985 and a touring exhibition in Japan in 1989. In both cases the latest date for exhibits was 1964, and 1975 was the latest date given in the chronologies in the exhibition catalogues. In many ways these are natural dates to choose. Lanyon's death in 1964 was obviously a watershed; 1975 saw the coincidence of the deaths, within a matter of a few weeks of each other, of Bryan Wynter and Roger Hilton, followed a few months later by that of Barbara Hepworth.

But of course many St Ives artists continued their careers. Ben Nicholson sustained a remarkable level of work to the very end of his life. Artists such as Terry Frost, Wilhelmina Barns-Graham, Denis Mitchell, Paul Feiler, John Wells

and Patrick Heron have continued to live and work in West Cornwall. Indeed artists from a variety of backgrounds, some Cornish, continue to work here. The art of older figures such as John Tunnard or Alan Lowndes, and of those pursuing individual paths such as Karl Weschke, can also be considered as belonging to the St Ives School. The remarkable talent of Bryan Pearce continues to flourish. Yet others have moved on from St Ives after a fruitful period in the area, a notable example being the Irish artist Tony O'Malley, who after two decades in Cornwall has seen his work flourish once more on his recent return to his native country.

Many of the senior artists based in West Cornwall continue to exhibit and teach and to participate in historical surveys, critical debate, and publications about St Ives art. All this has been reinforced by successful exhibitions around the world – particularly in the United States, Canada, Australia and Japan – of individual artists, from Hepworth and Nicholson, to the so-called middle generation.

Today many younger artists work in West Cornwall. Some are directly associated with the leading St Ives figures of the older generations, some simply have a new commitment to living and working in West Cornwall alongside new groups and in partnership with new galleries.

One legacy of the extraordinary level of artistic activity in West Cornwall since the nineteenth century, is that at

present there are five public art galleries and at least twelve commercial galleries in the region, together with a variety of other organisations and institutions, all committed to showing new art. There are probably around four hundred professional artists working in Penwith and West Cornwall alone – over two hundred and fifty gave works to a fundraising auction for Tate Gallery St Ives. The context for this, it should be remembered, is a resident population the equivalent of Cambridge or Carlisle, scattered around the moors and coasts west of Truro and Falmouth, as far as Land's End.

The opening displays in the new Tate Gallery St Ives, follow the pattern set by the 1985 Tate exhibition and its Japanese counterpart. But part of the role of the new Tate Gallery St Ives will be to build on its initial presentations of the Tate's collection of modern art in Cornwall. This will be both through new acquisitions and by stimulating responses to the displays through its Education and Projects programmes. Working with younger artists and with visitors to the region, in collaboration with partners in the South-West, as well as nationally and internationally, and by new additions to the collections and displays, Tate Gallery St Ives will aim to present a picture of art in the region which will be in the future as rich and diverse as its history deserves.

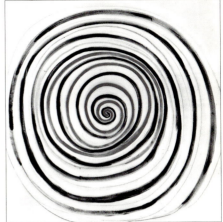

Further Reading

There are very few general books on St Ives art in print; the two exhibition catalogues asterisked are the best reference works to date. There are various publications planned for 1993 and 1994, and Tate Gallery St Ives will make available further more detailed bibliographies as part of its education and publications programme.

The following are a selection of publications which are relatively widely available through libraries. All books are published in London unless otherwise stated.

Denys Val Baker, *Paintings from Cornwall,* Cornish Library, Penzance 1950

J.P. Hodin, 'The Cornish Renaissance', *Penguin New Writing,* no.39, 1950

Denys Val Baker, 'Paintings from Cornwall', *Cornish Review,* Spring 1951

Lawrence Alloway (ed.), *Nine Abstract Artists,* Tiranti 1954

Patrick Heron, *The Changing Forms of Art,* Routledge and Kegan Paul 1955

Six Painters from Cornwall, exh. cat., Montreal City Art Gallery 1955

Dimensions: British Abstract Art 1948-1957, exh. cat., O'Hana Gallery 1957

Statements: A Review of Bristish Abstract Art in 1956, exh. cat., Institute of Contemporary Arts 1957

Denys Val Baker, *Britain's Art Colony by the Sea,* George Ronald 1959

Penwith Society of Arts, Tenth Anniversary Exhibition, exh. cat., Arts Council 1960

Denys Val Baker, *The Timeless Land: The Creative Spirit in Cornwall,* Adams and Dart, Bath 1973

Cornwall 1945-1955, exh. cat., New Art Centre 1977

The Art of Bernard Leach, exh. cat., Victoria and Albert Museum 1977

Bernard Leach, *Beyond East and West: Memoirs, Portraits and Essays,* Faber and Faber 1978

Artists of the Newlyn School 1880-1900, exh. cat., Newlyn Orion Galleries, Penzance 1979

Peter Davies, 'Notes on the St Ives School', *Art Monthly,* no.48, July/Aug. 1981

Adrian Lewis, 'The Fifties: British Avant-Garde Painting 1945-1956', *Artscribe,* no.34, March 1982; no.35, June 1982

Peter Davies, 'St Ives in the Forties', *Artscribe,* March 1982, no.84

Ben Nicholson: The Years of Experiment, 1919-39, exh. cat., Kettle's Yard, Cambridge 1983

Peter Davies, *The St Ives Years: Essays on the Growth of an Artistic Phenomenon,* The Wimborne Bookshop, Wimborne 1984

Denys Val Baker, 'Primitive Visions', *Country Life,* vol.176, 16 Aug. 1984

Tom Cross, *Painting the Warmth of the Sun: The St Ives Artists 1939-75,* Alison Hodge, Penzance/Lutterworth Press, Guildford 1984

**St Ives 1939-1964,* exh. cat., Tate Gallery 1985

Alfred Wallis, Christopher Wood, Ben Nicholson, exh. cat., Pier Arts Centre, Stromness 1987

**St Ives,* exh. cat., Setagaya Art Museum/ The Japan Association of Museums 1989

George Melly, *Alfred Wallis: Paintings from St Ives,* Kettle's Yard, Cambridge, University of Cambridge with Redstone Press 1990

A Painter's Place: Bank's Head, Cumberland 1924-31, exh. cat., Abbot Hall Art Gallery, Kendal 1991

Sven Berlin, *Alfred Wallis – Primitive,* reprinted by The Redcliffe Press, Bristol 1992

British Printmakers, 1853-1953, Century of Printmaking from the Etching Revival to St Ives, Garton and Co. in association with Scolar Press 1992

Acknowledgments

I must acknowledge the work of both present and previous Tate Gallery curators upon which most of the material used and quoted in this publication is based. The chronological essays by David Brown which have appeared in various publications have also proved invaluable.

In preparing this publication and the material for the opening displays at the Tate Gallery St Ives I have benefited greatly from conversations with Sven Berlin, Sir Alan and Lady Bowness, Eldred Evans and David Shalev, Terry Frost, Wilhelmina Barns-Graham, Patrick Heron, Andrew Lanyon, Janet Leach, Brian Smith, John Wells, Cornelia Wingfield-Digby and Monica Wynter. I am particularly grateful to Katherine Heron for furnishing information on Tom Heron and Alec Walker. I would also like to thank Janet Axten, Hazel Berriman, Toni Carver, H.C. Gilbert, John Halkes, Lady Carol Holland Rowan James, Liz Knowles, Alan Livingston, Roger and Janet Slack, Lu Simmons, Roy Ray and Marion Whybrow. A host of other people, far too many to list here, have helped myself and the staff of the new Gallery in its pre-opening period, and my thanks go to them all. I was lucky enough to discuss this publication and the new Gallery with Denis Mitchell, and it is a great sadness to me that he did not see his work installed in the new building.

Amongst the lenders to the opening displays to whom we are indebted are the Director and Committee of Kettle's Yard, Cambridge, Michael Nicholson, Sir Leslie Martin, and private individuals who wish to remain anonymous.

In addition I must thank the staff involved in the Tate St Ives at the Tate Gallery, the Steering Group of Cornwall County Council and the members of the St Ives Tate Action Group for the support they have given so far. The staff of the new Gallery look forward to working with them all in the future.

Michael Tooby

Donors

Founding Benefactors

Cornwall County Council
European Regional Development Fund
Department of the Environment
The Foundation for Sport and the Arts
The Henry Moore Foundation
The Sainsbury Family Charitable Trusts
St Ives Tate Action Group and its
 Supporters

Principal Benefactors

Penwith District Council
Trustees of the Carew Pole Family
 Trusts

Benefactor

The Baring Foundation
The John S. Cohen Foundation
Friends of the Tate Gallery
Rural Development Commission
Western Morning News, West Briton,
Cornish Guardian and The Cornishman

Donor

Barclays Bank PLC
British Gas South Western
British Telecommunications plc
Cable & Wireless
Christie, Manson & Woods Limited
Crafts Council
English China Clays plc
The Esmée Fairbairn Charitable Trust
Pall Europe Ltd
Pilgrim Trust
St Ives Town Council
Sotheby's
South Western Electricity plc
The Summerfield Charitable Trust
Television South West limited
TSB Foundation for England & Wales
Nina and Graham Williams

Sponsor

South Western Electricity plc

Appeal Donors

Coordinated by the Steering Group for
the Tate Gallery St Ives and the St Ives
Action Group.

Mr and Mrs Philip Alford
Viscount Amory Charitable Trust
Sir Eric and Lady Ash
Ms Gillian Bailey
Miss Nancy Balfour OBE
Barbinder Trust
Barclays de Zoete Wedd
Mr Peter Barker-Mill
Miss Wilhelmina Barns-Graham
BICC Group
Mr Simon Bennet
Patricia, Lady Boyd and Viscount Boyd
Cable & Wireless plc
Carlton Communications
Mr Francis Carnwath
Cloakworth Limited
Mr Peter Cocks
Commercial Union Assurance
Miss Jean Cooper
Craft Contracts
Dartington Hall Trust
D'Oyly Carte Charitable Trust
Dewhurst House
Dixons Group plc
Mr and Mrs Alan Driscoll
The John Ellerman Foundation
The Viscount and Viscountess Falmouth
Forte PLC
Mrs Miriam Gabo
Mr A.M.J. Galsworthy
J. Paul Getty Jr Charitable Trust
Gimpel Fils
Grand Metropolitan Trust
Mr Gordon Hepworth
Ms Judith Hodgson
Sir Geoffrey and Lady Holland

Mr and Mrs Philip Hughes
Mr Bernard Jacobson
Mr John Kilby
Mr and Mrs David Landale
Lord Leverhulme's Trust
Lloyds Bank plc
The Manifold Trust
Mark Armitage Charitable Trust
Marlborough Fine Art
The Mayor Gallery
Mercury Asset Management
Meyer International plc
The Monument Trust
National Westminster Bank plc
New Art Centre
Patricia, Lady Osborn and Mrs Ellis Jones
 in memory of Mr and Mrs James Read
Mr and Mrs John Pethybridge
Phillips Fine Art Auctioneers
Post Office
The Joseph Rank (1942) Charitable Trust
Mr Roy Ray
The Rayne Foundation
Mr Martin Rewcastle
Rotary Club of St Ives
Royal Bank of Scotland
Mr and Mrs Victor Sandelson
Schroder Charity Trust
Mr Nicholas Serota
Mr Roger Slack
Wing Commander H.M. Sinclair & Mrs
 Sinclair 1964 Trust
South West Arts
South West Water plc
Trustees of H.E.W. Spurr Deceased
The Hon. Piers St Aubyn
Mr and Mrs Ian Stoutzker
Sun Alliance Group
Thomas Gibson Fine Art Ltd
Mr and Mrs P. Throssell
Ms Maria Torok
Toshiba Corporation
Unilever
Mrs Angela Verren Taunt

Weinberg Foundation
Wembley plc
Westlake & Co
Mr and Mrs Derek White
W.H. Smith Ltd
Wingate Charitable Trust
The Worshipful Company of
 Fishmongers
The Worshipful Company of
 Goldsmiths
The Worshipful Company of Mercers
Mrs Monica Wynter

Founding Fellows of Tate Friends St Ives

Sir Leonard and Lady Allinson
Lady Banham
Mr F.H. Copplestone
Mr Michael Foreman
Miss Eileen Harris
Mr Alan John
Mr E.J.B. Jones
Mrs Vera Morrison
Mr R.H.C. Robins
Mrs V. Royston
Mrs B.B. Spring
Mr M. Stone
Ms Elisabeth Webb
Ms Nina Zborowska

and those donors who wish to remain
anonymous

be in the
the date

ped
splay

BOOK LOAN

Please RETURN or RENEW it no later
than the last date shown below